# TRADITIONAL JAPANESE STENCIL DESIGNS

### Edited by
## Clarence Hornung

Dover Publications, Inc., New York

# To SARA
## 1900 : 1981

### In Sweet Remembrance

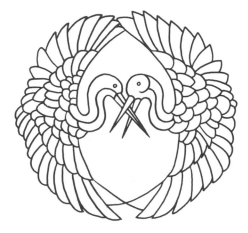

Published in Canada by General Publishing Company, Ltd., 30 Lesmill Road, Don Mills, Toronto, Ontario.

*Traditional Japanese Stencil Designs,* a new work first published by Dover Publications, Inc., in 1985, consists of an Introduction by Clarence Hornung and a selection by him of plates from published Japanese sources.

### DOVER *Pictorial Archive* SERIES

Manufactured in the United States of America
Dover Publications, Inc., 31 East 2nd Street, Mineola, N.Y. 11501

**Library of Congress Cataloging in Publication Data**
Main entry under title:

Traditional Japanese stencil designs.

(Dover pictorial archive series)
1. Stencil work—Japan—Themes, motives.   I. Hornung, Clarence Pearson.   II. Series.
NK8665.J3T7   1985        745.7'3        84-21254
ISBN 0-486-24791-0

# INTRODUCTION

The vast panoramic scope of Japanese design, infinite as the heavens and boundless as the seas, is deeply rooted in the realm of nature. A reverence for all living things, an integral part of Buddhist and Shinto religions, engenders an awesome sense of beauty that embraces natural forces and animate creatures seldom glorified in the cultures of the West. Trees, mountains, rivers and celestial bodies are embodied as deified spirits, sanctified and worshipped with awe and affection. Sun, sky and sea . . . birds, beasts and butterflies . . . countless flora and fauna . . . these are the omnipresent elements of nature that provide and enrich the Japanese design vocabulary. For ages and ages these have served the artist symbolically and as embellishment and ornamentation, not only on kimonos and household goods but also on objects of sacred use in shrines. Woven textiles with delicate floral patterns and metalwork decorated with arabesques, blossoms and beasts appear as early as the Heian period (794–1185). Lacquers and items for personal use were decorated with naturalistic themes; the more personal the purpose, the more detailed and delicate the ornamentation.

In the gradual process of continuing development the Japanese craftsman learned to adapt and simplify design forms until they attained a degree of purity through progressive evolution. Each motif reached a stage of graphic perfection akin to shorthand symbols, which made their application to decorative usage ideal. For example, one can make a case study of the chrysanthemum (*kiku*), Nippon's imperial flower, and observe literally hundreds of variants so greatly conventionalized in construction and arrangement of petals as to produce endless diversity of decorative interpretations. This extraordinary talent of the Japanese to reduce representational forms to ideographic motifs makes patterns inviting, intriguing and always optically exciting.

To attempt an inventory of these sources of inspiration would be as hopeless as trying to count the heavenly bodies on a clear, starry night. Yet some simple classification would be helpful in categorizing the boundless domain of the world of nature. Above all, the heavens have held an endless fascination for the Japanese. Cloud patterns (*kumo*) assume many different forms, often cumulus, wavy or nebulous, changing into mist (*kasumi*). Lightning (*inazuma*), with its martial connotations and the thunderbolt, lends itself to stylization, suggesting fecundity and the basic forces of life. Most familiar in Japanese prints and paintings, and carried over into graphic representations, is the moon (*tsuki*) in its various phases, perennially suggestive of poetic imagery. It is often combined with other motifs that can be traced back to Chinese origins as a manifestation of *yin*, the passive or female force in the universe. Just as the early Japanese of the Nara and Heian periods borrowed freely from Chinese astrology, so the stars (*hoshi*) have figured prominently in traditional pattern decoration of the Japanese. The star as a symmetrical entity or used in groups of three, five or seven was popularized by the shogun and warrior classes for centuries past. But the capstone of all heavenly bodies remains the sun (*hi*), which appears as the big red disc or "rising sun" that had its origins over a thousand years ago. It was in 1854, coinciding with Admiral Perry's epochmaking treaty, that it was adopted as a national emblem and shortly thereafter as the imperial emblem on the nation's flag. The firm basis for the sun's universal acceptance lies in the legends that trace the origins of the imperial line to the Sun Goddess. The completeness of the circular disc, without beginning or end in its linear outline, accounts for its versatile use as a design motif and its persistent popularity in all forms of decoration.

When the Japanese designer turns his attention to the botanical world of trees, plants, buds, blossoms and flowers, he taps a wealth of untold riches, so vast in the scope of its bounties that few Western cultures approach its infinite resources. The bamboo (*take*) has no rival in the great adaptability of its many parts: stem, leaf form, canes and overall outline. Its grace and versatility have made it extraordinarily popular since ancient times, when it was imported from China. Developed into 150 varieties, the bamboo's usefulness extends into many disparate fields including structural materials, fencing, basketry, brooms, rakes, hats, ladders, lattices, arrows, flutes, fishing rods and even foodstuffs. It is not surprising in view of such universality that to the decorator it offers unlimited design choices in combinations of leafy fronds, cane shoots and bud formations. For sheer grace and elegance the overlapping stems and cane shoots, enriched with their delicate leaf forms, invite caprice and playfulness, always a visual delight in endless combinations. In contrast to the bamboo, the stately coniferous cryptomeria (*sugi*) offers its majestic form to indicate and symbolize Shinto *torii* and shrine gables and gateways, while its slender needles have inspired many intricate design arrangements.

A favorite theme with artists, poets and writers is the cherry blossom (*sakura*), far outstripping other blooms in its manifold applications. From about the tenth century onward it was so popular that it was referred to merely as "the flower," or *hana*. Its nearest rival is the chrysanthemum (*kiku*), the

Japanese imperial flower. Its formalized sixteen-petal arrangement radiating out from its center suggested the sunburst, and so it came to be referred to as "sun splendor" (*nikka*) and the "sun spirit" (*nissei*), whose origins go back several thousand years in time. This regal flower symbolized the finest and highest aspirations in the spiritual and temporal world. There are reputed to be as many as five thousand varieties of the chrysanthemum in a profusion of colors, sizes, shapes and forms. It follows quite naturally that in the arts and crafts such widespread omnipresence should be reflected in far-ranging decorative applications.

The gingko tree (*ichō*), like so many other plants and trees, was brought over from China in ages past, and is to be found lining the city streets as well as adorning the grounds of temples and shrines. Its beauty is greatly admired, especially since, in autumn, its leaves turn into a blaze of yellow glory. The slender grace and stems of the iris (*kakitsubata*), the fragrance and beauty of its ragged petals, made it a popular decorative device on textiles, clothing and carriages of the court nobility from the Heian period onward. Everywhere in Japanese gardens and flower arrangements one finds that ivy (*tsuta*) plays a prominent role. Since it is known to entwine itself around other bodies, it was adopted by women of pleasure who found in its gracefulness qualities for admiration.

The mandarin orange (*tachibana*) was a favorite fruit and popular for its succulent taste, beautiful fragrant blossoms and glossy green leaves. The leaf of the maple (*kaede*), because it affords so much beauty in its autumnal coloring, figures prominently in the foliage-viewing festivities upon which the Japanese place so much emphasis. The leaf formation reminded the ancients of the shape of the frog's foot. The oak leaf (*kaji-ba*) closely resembles the mulberry in appearance. In ancient times the leaf was used as a dish for serving food, and thus became associated with offerings to the gods. The strength and majesty of the oak made it a favorite with the warrior class as a symbol of power and vitality, and so it appeared frequently as a design motif on clothing and textile patterns.

The paulownia (*kiri*) runs a close second to the chrysanthemum as an imperial crest. Its popularity dates back to about the thirteenth century, when the ruling class of shoguns selected it as a mark of favor on all objects from clothing to military paraphernalia. From this time forward the prestigious paulownia conveyed an aura of aristocracy and power. The major military leader Hideyoshi had it engraved, emblazoned and incised on all his monumental projects and buildings. The leaf and blossoms of this plant offer much variety in its graphic renderings, and so it has continued for centuries on countless objects of beauty.

In the evergreen family of trees, besides the cryptomeria the pine (*matsu*) is a tree for all seasons. Resistant to wind and resilient under heavy snows, it became an auspicious symbol of longevity. To celebrate the New Year its branches of cones and needles are placed over the doorway of a home to usher in a new period of peace, good health and prosperity. The various pine elements—the overall tree form, conifers, branches and needles—all augment the pattern possibilities inherent in its natural beauty. Another versatile plant form is the delicate and fragile plum blossom that appears early in spring regardless of lingering winter chills and snows. Thus it was ranked alongside the bamboo and pine as one of the East's traditional "three companions of the deep cold." The plum was a favorite fruit, and dyestuffs were derived from the brilliant red-blossomed variety. The five petals of the plum blossom have become extremely useful as the ingenious designer allows full play to his imagination.

No lovelier massing of purple blossoms is to be found than those of the ever-popular wistaria (*fuji*), whose clusters of soft flowers trail downward as they are trained to grow on arbors and trellises. Wistaria-viewing parties date back over a thousand years to the reign of Emperor Daigo. The powerful clan of Fujiwara (meaning "field of wistaria") made prominent use of the graceful motifs in landscape painting and textile design. In the far-reaching realm of Japanese design the wistaria occupies a unique place because of both the delicacy and intricacy of its patterning opportunities.

Many other plant and floral forms have contributed to enrich the Japanese vocabulary of decoration. It would be very difficult to list them all, for the craftsman is ever alert to introduce new renditions and broader use of lesser known species in order to develop innovative compositions. There is the arrowroot (*kuzu*), known to be one of the "seven roots of autumn"; bellflower (*kikyō*), indigo in color; bracken (*warabi*), emerging in early spring; clove (*chōji*), a greatly prized spice; bush clover, or lespedeza (*hagi*), another of autumn's plants; cosmos (*kosumosu*) and dahlia (*daria*), more recent imports from foreign lands; fern (*shida*); forsythia (*rengyō*); gardenia (*kuchinashi*); gentian (*rindō*); grape (*budō*); the leaf of hemp (*asanoha*), identified as one of the five basic grains of China; hollyhock (*aoi*), native to Japan; lily (*yuri*); lotus (*hasu*); mistletoe (*hoya*); morning glory (*asagao*); mulberry (*kaji*); narcissus (*suisen*); orchid (*ran*); palm (*shuro*); pampas grass (*susuki*), another of the "seven plants of autumn"; passion flower (*tessen*); peony (*botan*), another import from China, called "the sovereign of the flowers"; persimmon (*kaki*); pomegranate (*zakuro*); poppy (*hinageshi*); rice plant (*ine*), the staff of life of much of Asia; and the tea berry (*chanomi*). And so the alphabetical list could go on endlessly enumerating the unlimited sources offered by the world of flora without ever exhausting its illimitable opportunities.

Interwoven with the stems of plant life and floral forms, delicately composed by the artist's own capricious choice, are innumerable creatures of the animal world from land, sea and air. Again, the range presents a vastness that defies inventory. We cannot touch upon more than a few of these motifs for which the Japanese have a special affinity. In the marine world, domesticated fish such as the carp, goldfish and angelfish play an important role, while offshore in the depths of this island nation's many waters the abundance of animate forms include shellfish, mollusks, crustaceans, tortoises and turtles. The tortoise shell (*kame*) has, over the centuries, been subjected to evolutionary stylization until the pure hexagonal design derived from its carapace has provided numberless adaptations. Many types of shells appear throughout the lexicon of decoration, a natural result of Japan's dependence upon products of the sea. The clam (*hamaguri*), sea fan (*itayagai*), roll shell (*kai*) and conch (*horogai*) occur frequently, often artfully interspersed with seaweeds, grasses and rhythmic wave patterns. The shrimp (*ebi*), crab (*kani*) and crayfish (*kurumachi*) form a basis for many intriguing patterns, often swirling in eddies of water or with decorative wave foam or

sprays. The fish net and seine sometimes provide the ornamental background for marine elements, enmeshed to give some realism to a natural affiliation.

Birds large and small, butterflies, dragonflies and the smallest insects all contribute in exciting profusion to enlarge the designer's vocabulary and the decorator's lot. The pattern-maker finds himself bewildered by the extent and variety of bird forms, congregating in flocks or singled out as a lone motif to be repeated ad infinitum. The swarming of bees, the fluttering of butterflies or the migrations of masses of birds catch and hold the designer's fascination. From either related natural plant forms or blossoms or arbitrarily chosen design shapes, the pattern-maker's instinct selects the best or discards elements that do not compose to his liking. Familiar sights in an island country are birds skimming over waves cresting in foam or swallows dipping low as they sweep over reeds, bamboo grasses or groves. The sparrow (*suzume*) and the swallow (*tsubame*) appear in paintings and patterns going back to ancient times. The crane (*tsuru*), symbolizing a thousand years of life, has a history of noble elegance and is featured in many compositions. It has always been a popular subject in paper-folding exercises (*origami*). The butterfly (*chō*), favored by the Japanese aristocracy as far back as the Nara period, continues to be popular to this very day. The exquisite decorative quality of this handsome creature makes it a willing accomplice for the designer. The crow (*karasu*) and the pigeon (*hato*) appear frequently in design arrangements, resembling each other in form and outline. The wild goose (*kari*), depicted in flight in its customary V-formation, enabled the designer to plan compositions readily susceptible to repeat patterns. The dragonfly (*tombo*), because it carried an alternative name (*shōgun mushi*), was referred to as the "victory insect." The phoenix (*hōō*), plover (*chidori*), quail (*uzura*) and long-tailed rooster (*onagadori*) provide a variety of avian forms each with roots in Japanese legends and history. The gull (*kamome*), again, is always associated with the sea and thus apears accompanied by sailboats or waves to emphasize its maritime affiliation.

From the world of mammals, by contrast, the designer limits his selection to comparatively few creatures of universal appeal. Smaller animals like the rabbit (*usagi*) and squirrel (*risu*) do appear. Larger beasts like the horse (*uma*), lion (*shishi*) and tiger (*tora*) are noted for their very infrequent occurrence.

Having explored the immensity of the world of flora and fauna and the inexhaustible opportunities offered in the repetition and multiplication of its elements, we now turn in another direction to examine the field of abstract and geometrical design. Here, in the realm of linear and plane forms, "boundless as the sea," the creative faculties of the designer find an array of circles, squares, diamonds, rectangles, hexagons and more complex polygons. Let's isolate and examine a single example: the square (*meyui*). The Japanese variants include the diamond-shaped square, rounded square, target square with enclosed circle, hanging cloth rectangle, "courtesan" rectangle, cut-cornered square, hollow-cornered square, indented square and zigzagged square, to name but a few. Similarly the circle, more fittingly described as the enclosure (*wa*), is labeled according to the nature of the encircling members, ranging from hairline to double line, triple line and "snake's eye." Decorative elements added to

the circular enclosure may include a wavy or "hazy circle," moon, snow, plum blossom, chrysanthemum, wistaria, bamboo, carriage wheel or arabesque—descriptive in each case of the outer treatment. A further extension into the limitless area of circular forms is the intricate study of that most intriguing of Japanese native designs, the family crest (*mon*). Dating back to the eleventh century with continuous use and development, some four thousand or more well-established *mon* form a background of inexhaustible riches incorporated into textile and costume design, especially for kimonos.

Stripes, bands and lattice motifs abound in the linear field, varying from the simple to wavy, zigzag or reticulated forms. These often acquire fanciful names, either descriptive or affiliated with shōgun or samurai families. We encounter nobleman (*daimyō*) stripes; random, broken or waterfall stripes; checkerboard, plaids and lattice patterns; double-lined and triple-lined lattices; *benkei, tachiwaki* or Yoshino lattice patterns. Outstanding designs include the traditional key fret (*sayagata*) incorporating the Buddhist swastika (*manji*), which persists and recurs in a variety of forms, both rectangular and obliquely distorted into a diamondlike structure. Another pattern favorite involves interlocking circles (*shippō*), used as a basis for many floral or other forms introduced for contrapuntal effect. A set of grouped triangles forming a six-pointed star is derived from the popular, conventionalized hemp-leaf pattern (*asanoha*). The tortoise-shell carapace (*kikkō*), stylized into pure hexagonal shapes, is one of the unique geometric patterns present in all types of Japanese decoration. Wickerware, canework and basketry, when conventionalized, result in many interwoven designs, while the imbricated fish scale provides the basis of semicircular patterning.

Highly sensitive to the enduring beauties of nature, the Japanese craftsman is impelled, however, to offset these with ordinary man-made objects that are a part of his daily life. These include a wide range of artificial things and utensils, the elements of the garden and building, the accoutrements of dress and costume, the simple appliances of hearth and home and the arsenal of swords, arrows and drums. Absorbed into the fabric of design, we note a studied contrast, at times subtle and playful, to achieve heightened interest. The games and battles of the feudal warring class gave rise to a whole battery of devices that included the arrow (*ya*), arrowhead (*yajiri*), battle-axe (*masakari*), bow (*yumi*) and target (*mato*). Common objects include the ball (*mari*), bell (*suzu*), bowl and chopsticks (*gosu ni hashi*), candle (*rosoku*), chessman (*koma*), coin (*sen*), comb (*akadori*), dice (*sai*), doll (*mamezo*), drum (*tsuzumi*), fan (*ogi, sensu*), fence (*mizugaki*), flag (*hinomaru*), headgear (*kasa, eboshi*), helmet crest (*kuwagata*), key (*kagi*), knot (*takaramusubi*), ladder (*hashigo*), lattice (*kōshi*), letter (*fumi*), mask (*shishi kashira*), measure (*masu*), mirror (*kagami*), net (*ami*), penny (*zeni*), pliers (*kuginuki*), plough (*karasuki*), raft (*ikada*), sailboats and gear (*ho, hogakebune, kaji, ikuri*), scissors (*hasami*), Shinto gateway (*torii*), sickle (*kama*), spools and reels (*itomaki, chikiri*), sword (*tsurugi*), tassel (*gyoyo*), top (*koma*), trivet (*gotoku*), umbrella (*kasu*), urn (*heishi*), weight (*fundo*), well crib (*igeta, izutsu*), wheel (*rimbo, kazaguruma, suisha*), wine vessel (*sakazuki*). This inventory of man-made goods could continue on ad infinitum because the Japanese, while following along traditional lines much of the way, are

ever on the alert to introduce new and novel compositions. The domain of the natural order is preeminent. However, this does not rule out the designer's need to blend the best of both worlds into an aesthetic admixture of endless variety and ambiance.

For general purposes Japanese textile design may readily be divided into two main categories: weaving and dyeing. There are different methods of dyeing using either paste or wax but the traditional method, called Yuzen dyeing, in use for the last several centuries, depends upon the use of handcut stencils called *katagami*, literally meaning "pattern paper." All the designs portrayed in this volume depend upon the use of rigidly cut stencils, the basis for the transference of designs to the textile cloth ultimately sold as yard or piece goods except for custom-made designs not for the general market.

The art of stencil-dyeing (*kata-zome*), thought to be at least a thousand years old, may be traced to two distinctly separate origins. On the mainland, in a region southwest of Tokyo called Mie Prefecture, the city of Suzuka is considered by leading authorities to be the birthplace of the stencil. It became the undisputed center of stencil-patterned textile production in Japan. During the period when stencil-decorated garments were most popular throughout the country, dealers in textile stencils from this region were protected by a government monopoly. Under the auspices of the ruling Tokugawa family, which controlled the Kii peninsula including present-day Mie Prefecture, stencil dealers were given unrestricted travel rights, unusual for members of the merchant class. From the early years of the eighteenth century onward, the highly developed branch of the textile industry was concentrated in this region and zealously guarded by the shōgun in control.

Concurrently, on the island of Okinawa, textile production from multicolored stencil designs reached the apogee of perfection, owing to the uniquely artistic creativity of their designs. Accounts vary on the origins of textile production on the island, some 55 miles southwest of Japan's southernmost island of Kyushu, but it is generally believed that merchant traders from Java, Borneo and the Philippines introduced the process several centuries ago. It is amazing that in this poor and isolated group of islands the art of weaving and dyeing took root and flourished, assisted by the cultural currents reaching Okinawa from Japan, China and Southeast Asia. An added factor grew out of the social system, which demanded that tribute be paid the local government aristocracy in fine textiles instead of money. The dyed patterns, often quite colorful, were used for women's kimonos, while those worn by men were more conservative in design and coloring. Okinawan textiles of exquisite stencil-dyed fabrics were called *bingata*, or colored patterns.

The process of dyeing textiles from stencils is principally a resist technique which involves covering the area to be protected with a soluble rice paste applied directly to the fabric. The white cloth is laid out on long tables made of movable boards, smoothed and straightened. The stencil is placed in position on the fabric and the resist paste is applied with a spatula, blocking out all areas that are to remain the cloth's natural color. After the application of the paste the stenciler then carefully removes the stencil and moves it to an adjacent position to repeat the process, continuing the entire length of the yardage to be stenciled. When the rice paste is thoroughly dry, the dyer applies the dye to the fabric with a brush. One or a number of colors may be applied as the design calls for. After dyeing has been completed the resist paste is washed away in water, and the portions that were protected from the dye remain the natural color of the fabric.

Special papers used in the process of stencil cutting were made from the inner bark of the mulberry (*kaji*). Soaked in the juice of aged persimmons (*kaki*), two or three sheets were laminated together. This copper-colored paper was then treated with a hard-drying oil, serving to waterproof it against the dissolving effect of the water-based resist paste used in the process of dyeing. The paper became stiff yet pliable and acquired an astringent fragrance.

The stencil cutter ordinarily stacked seven or eight sheets together for cutting. These were secured to prevent slippage by holes drilled around the edges of the stack, with twists of handmade paper pulled through the holes. The cutting process required the utmost skill and the sharpest of separate knives for the different cuts required by the pattern design. One was a type of awl (*kiri-bori*) with a small semicircular blade to cut minute holes. Another thin blade with a steeply diagonal edge and needle-like point, called *tsuki-bori*, was held by the fingers like a pencil and pushed away from the cutter. Thin blades with straight, curved or fluted edges called *ichimai-zuki* were held vertically and pushed into the stack of papers for special effects. Then there were a variety of punch-like knives (*dogu-bori*) used to create the minute patterns known as *komon*.

When we study the elaborate patterns involving hundreds of minute dots, squares, stripes and crisscrossing bands—with resulting interstices all to be skillfully cut through layers of paper—our sense of wonderment at the skill of the stencil cutter is unbounded. Only a small handful of these old-time craftsmen are alive to practice their almost forgotten art. In today's industrialized Japan with technological advances in every field of production these few craftsmen are singled out, as are those in other craft practices of yesterday, honored and revered as true "national treasures"—survivors in a fast-moving world that still remembers its past and recognizes its glories.

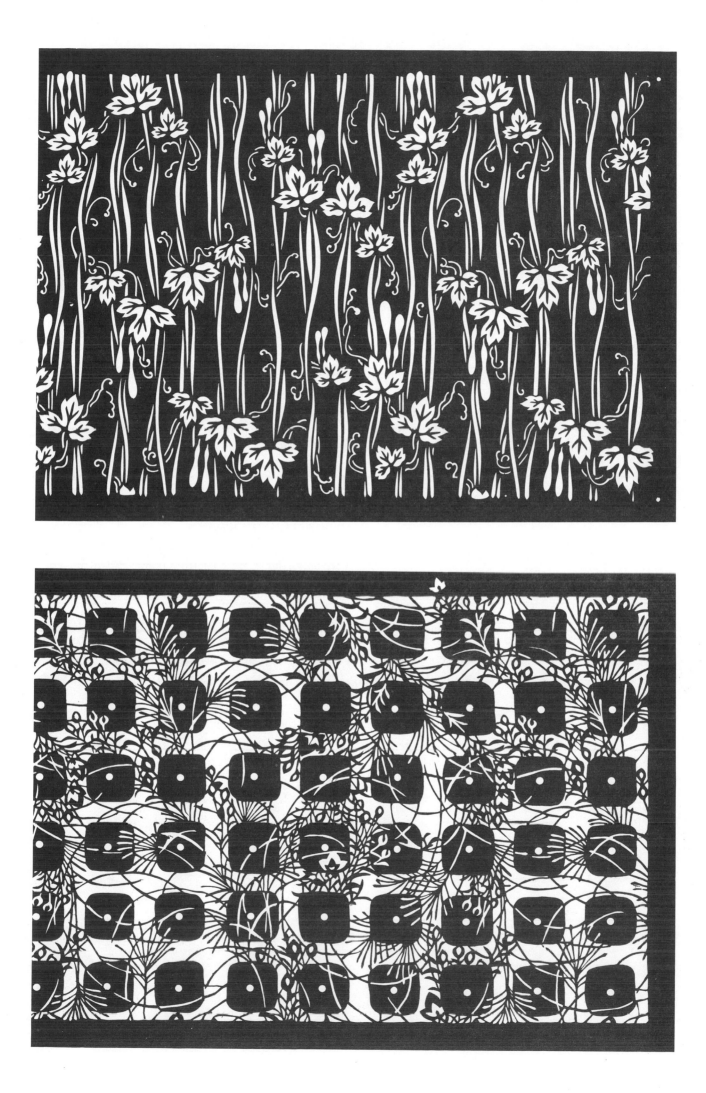

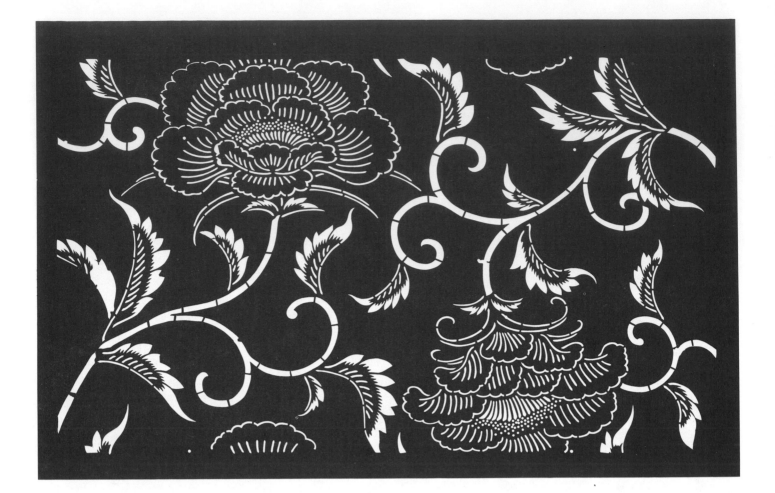

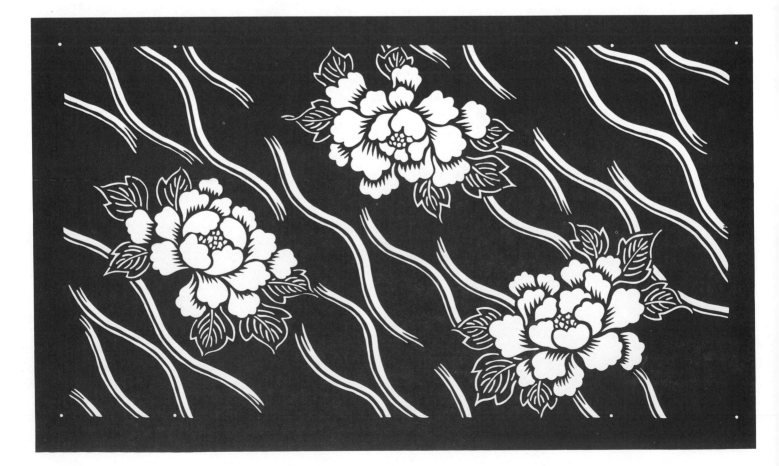

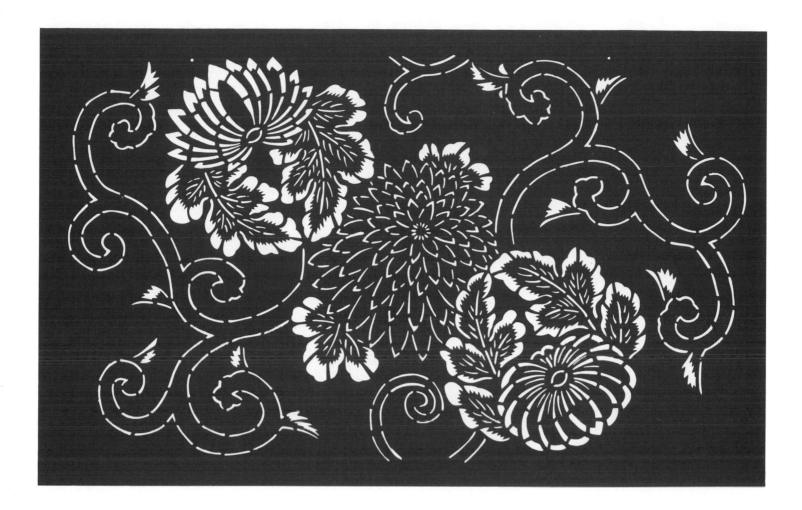

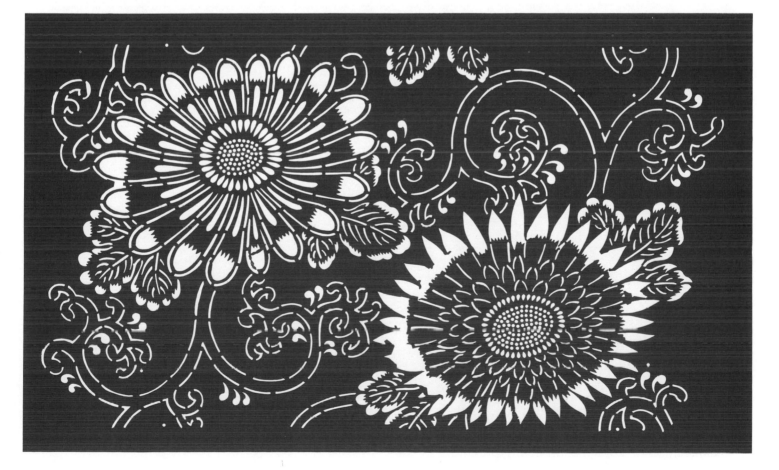

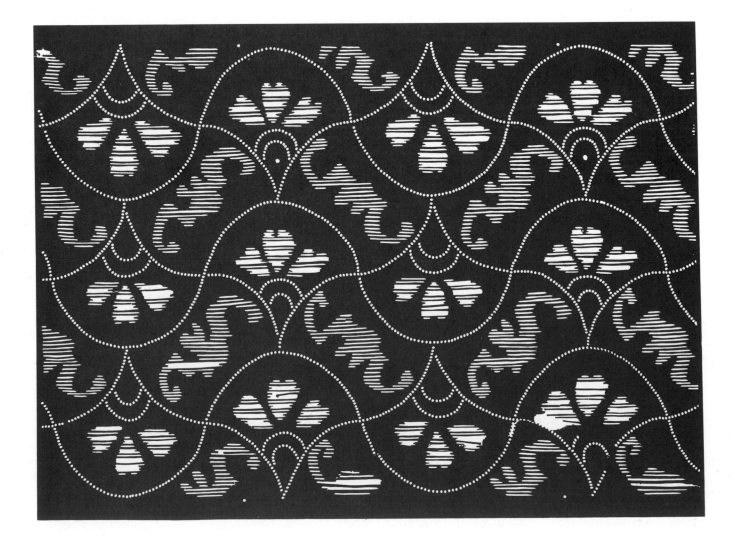

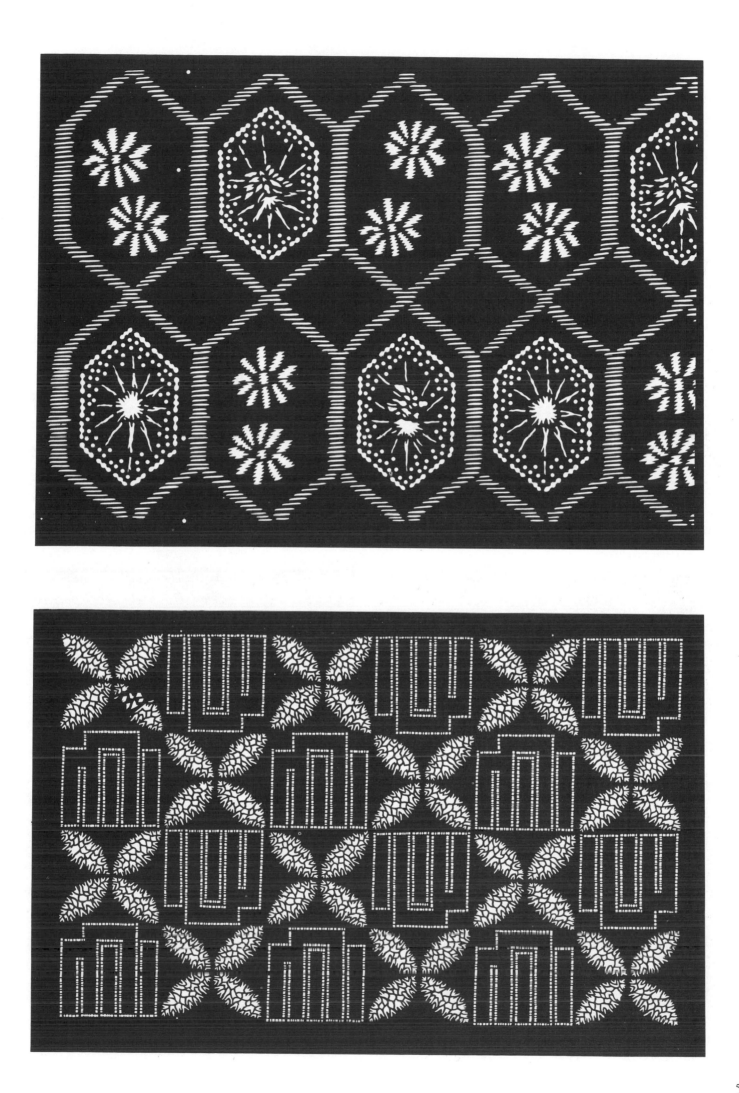

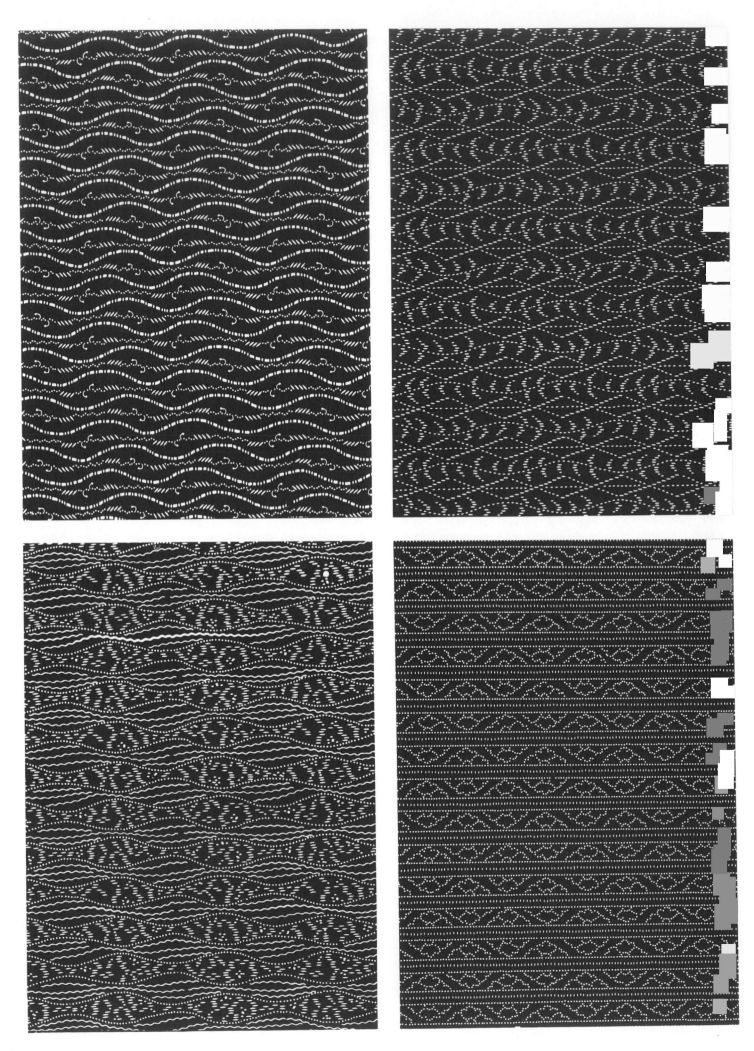

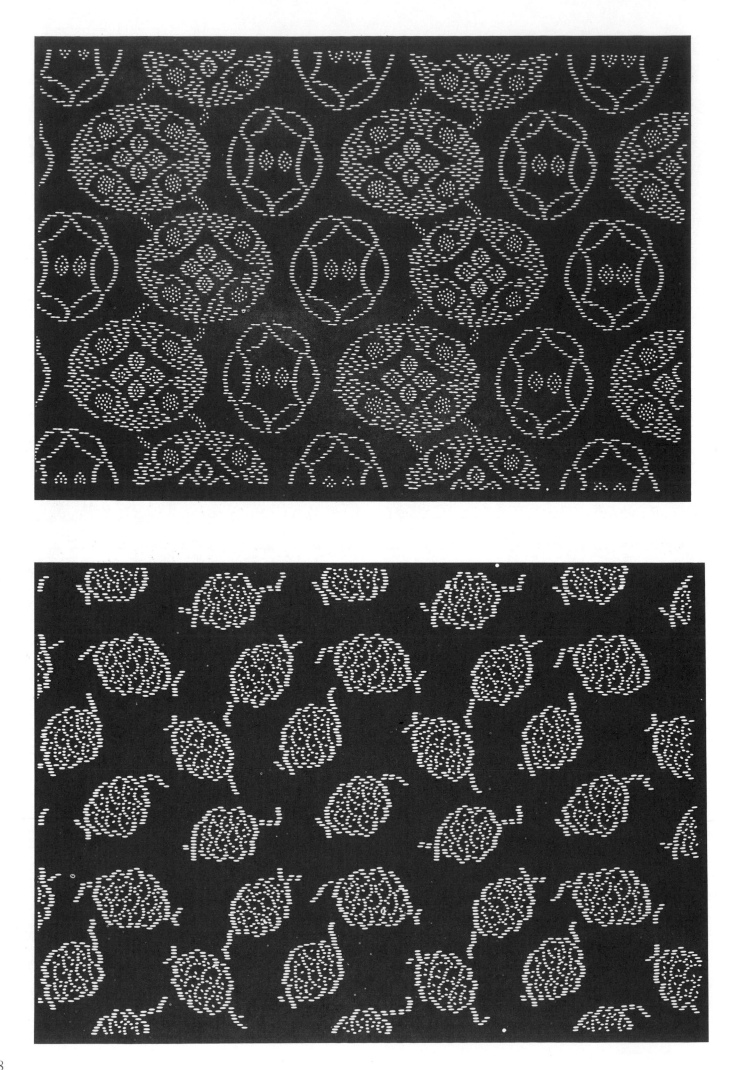

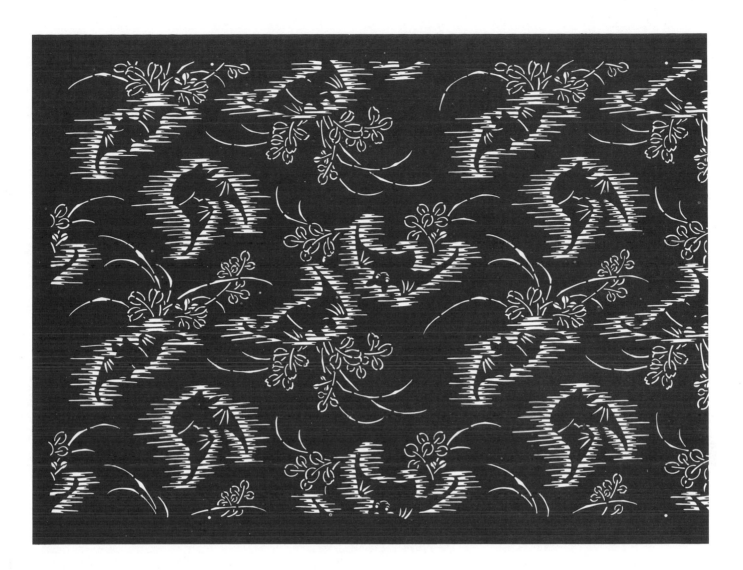

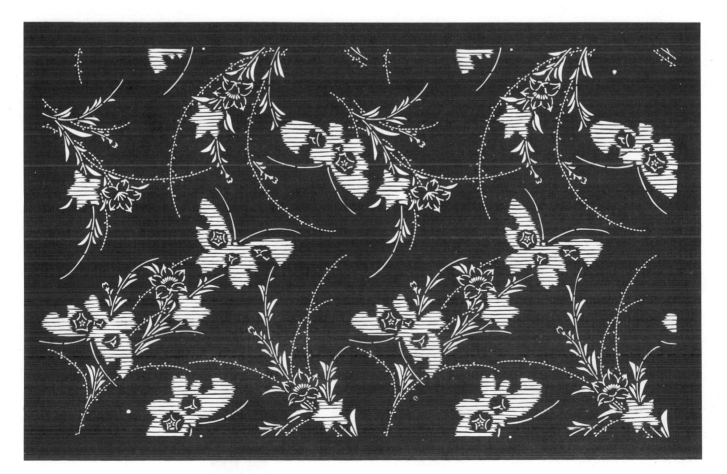

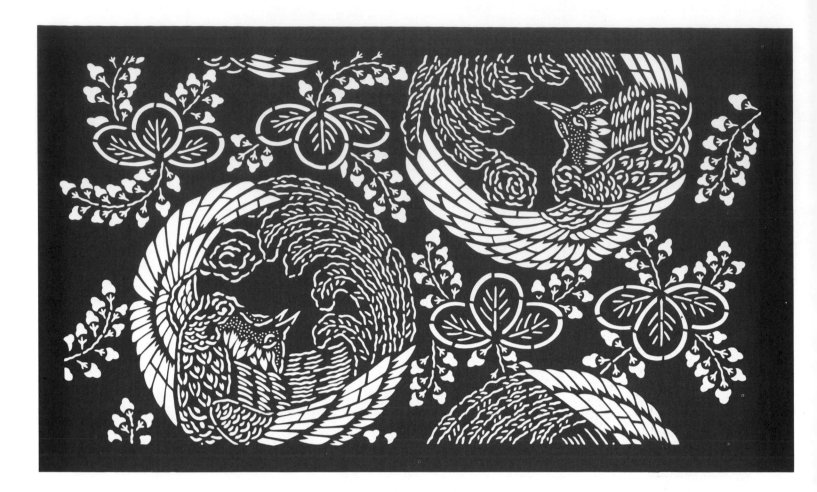

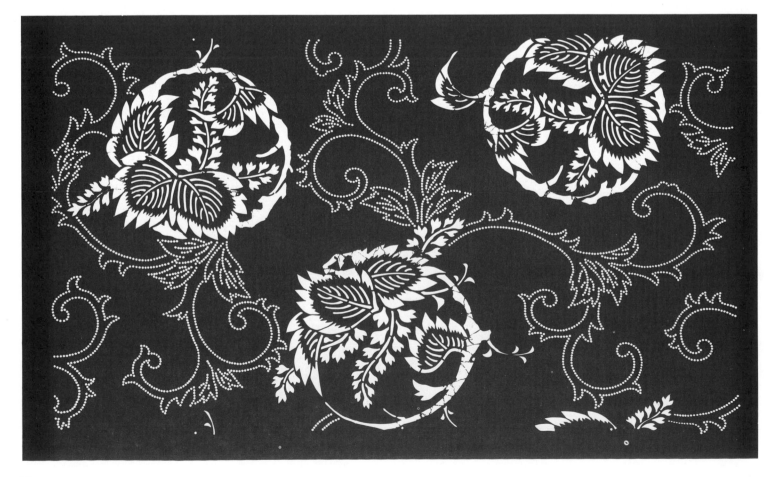

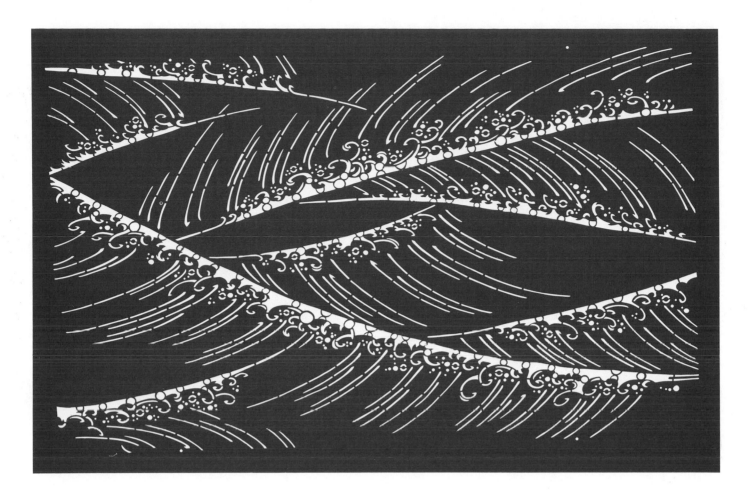

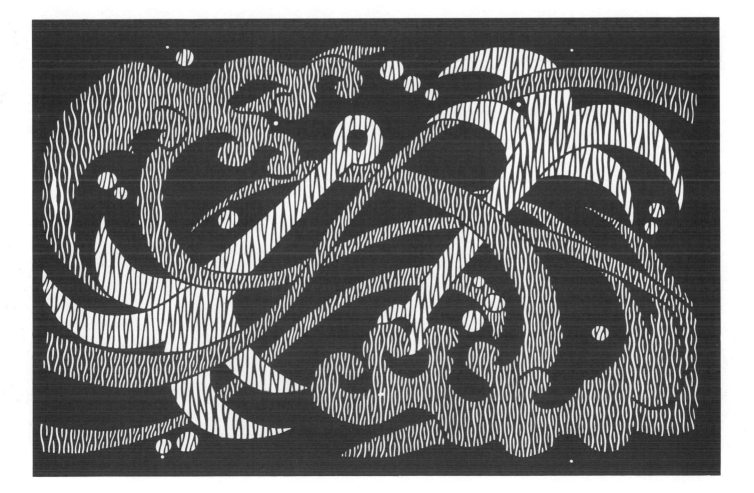

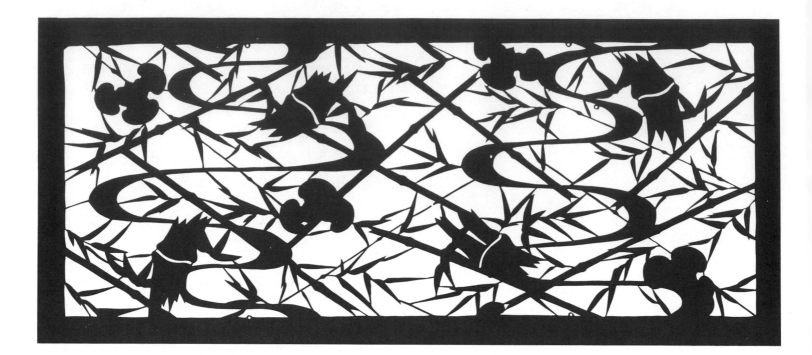

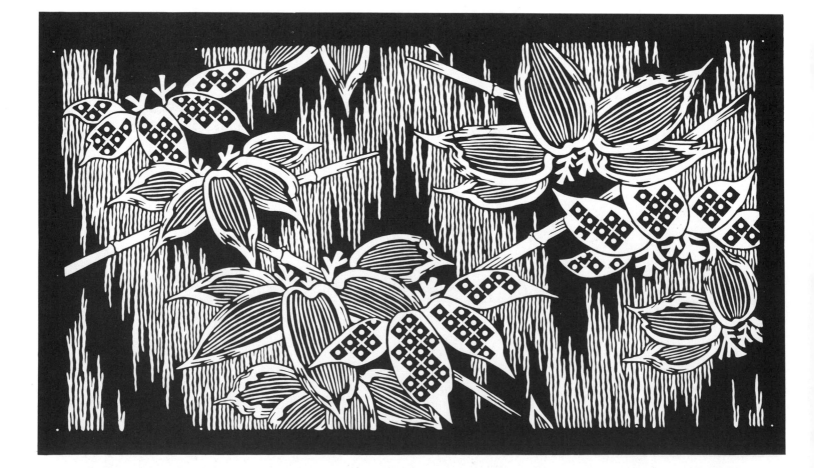

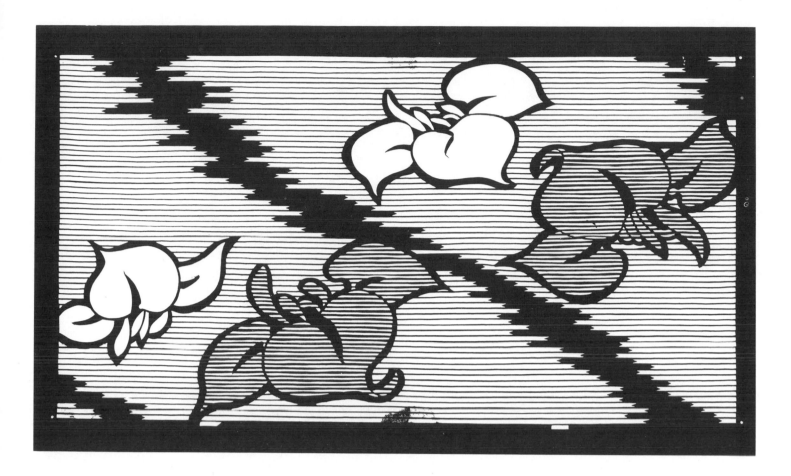

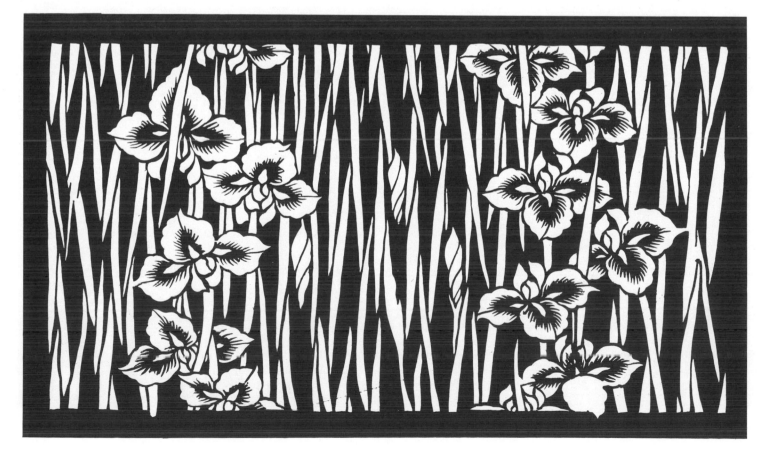

14

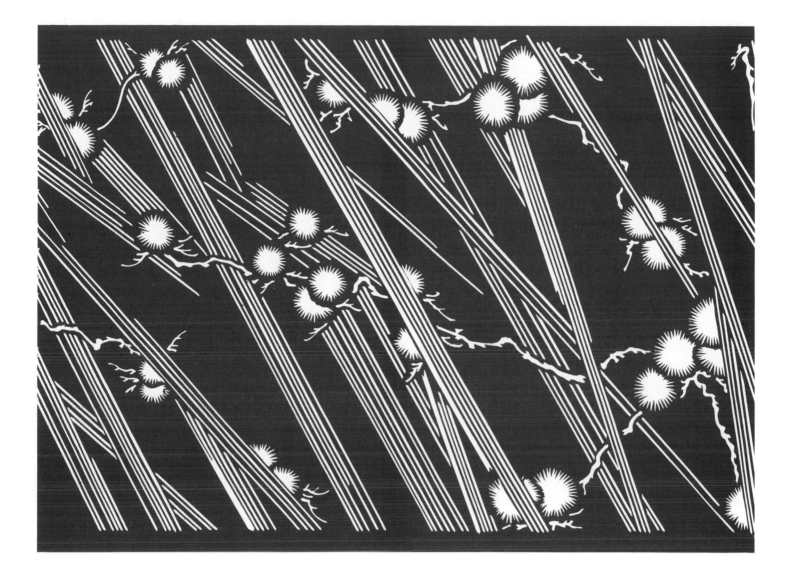

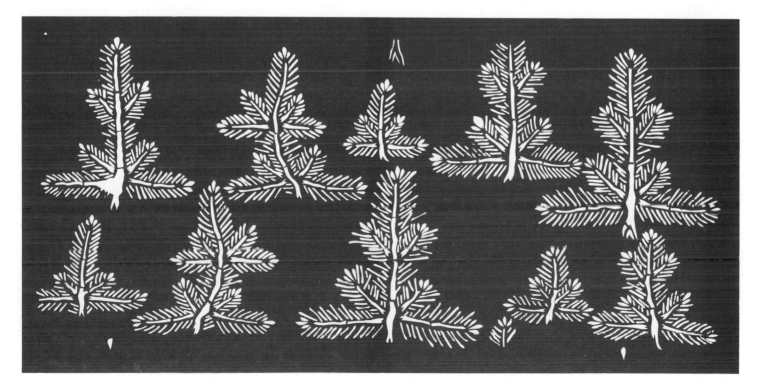

15

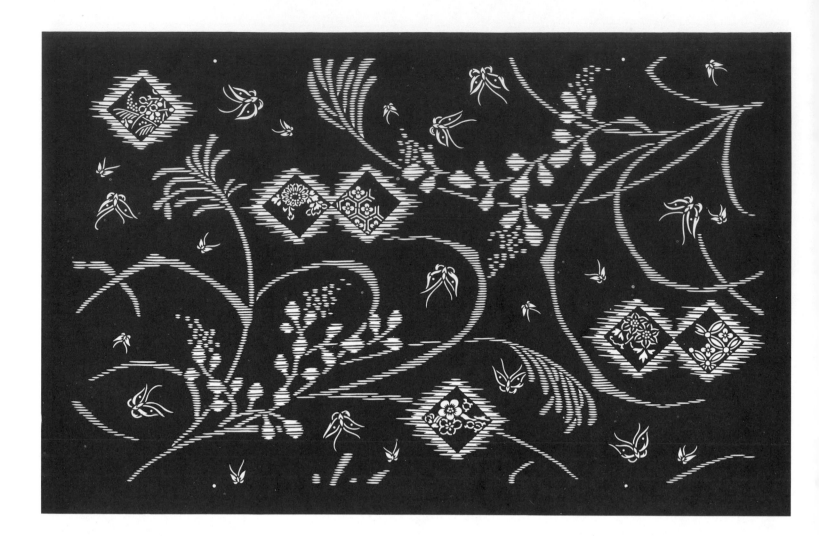

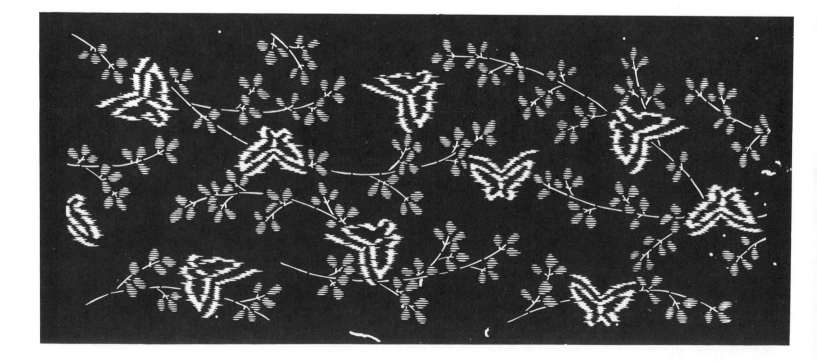

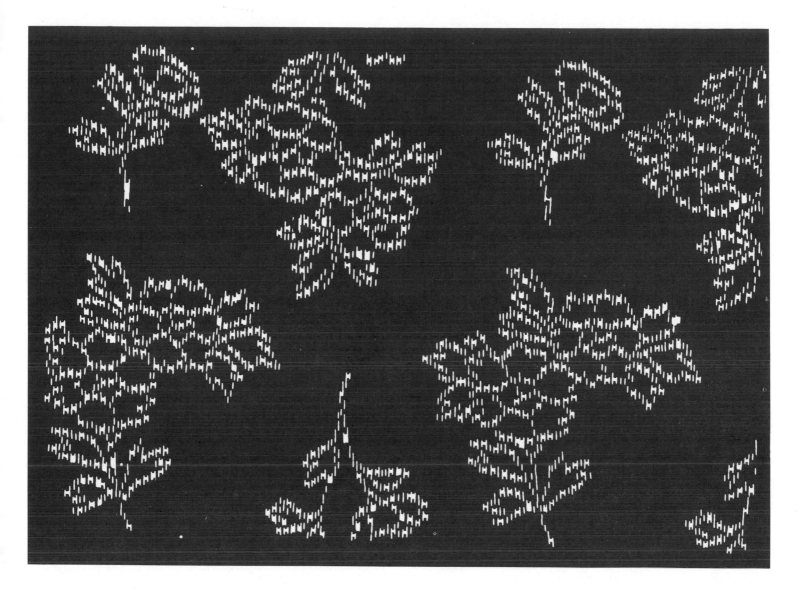

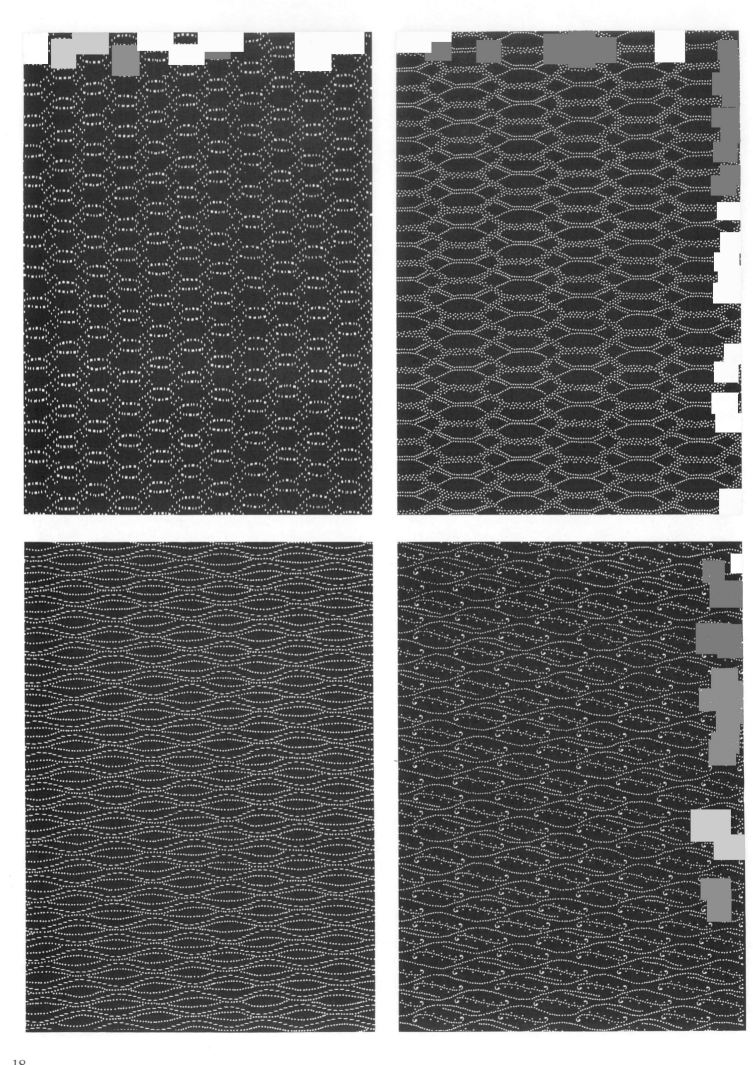

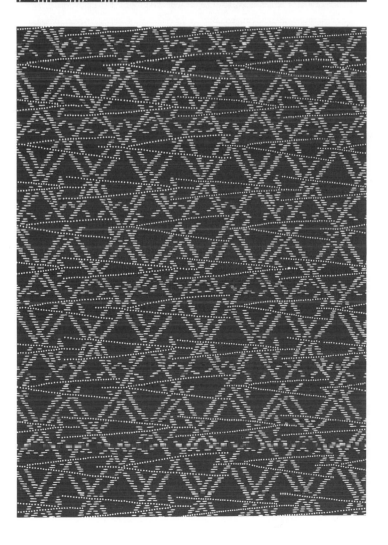
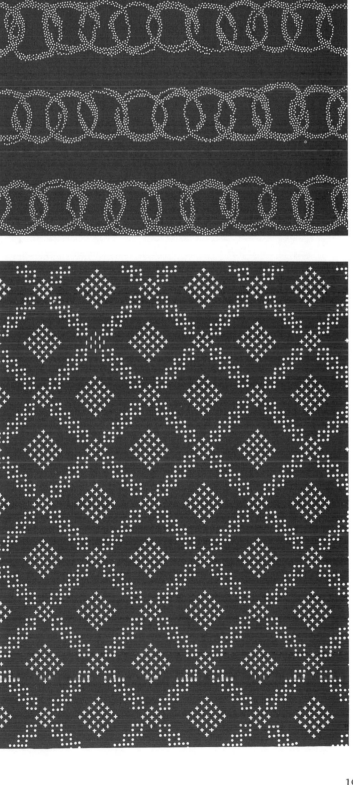

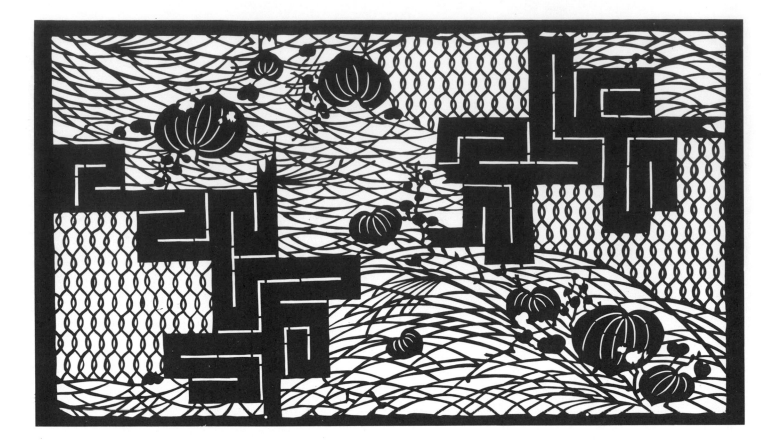

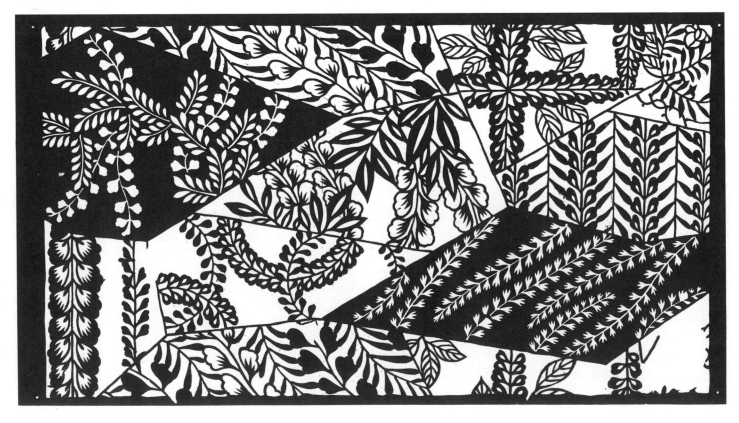

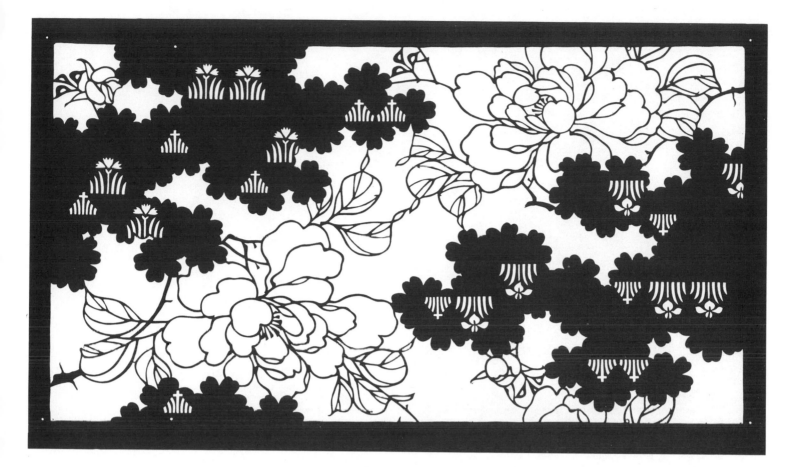

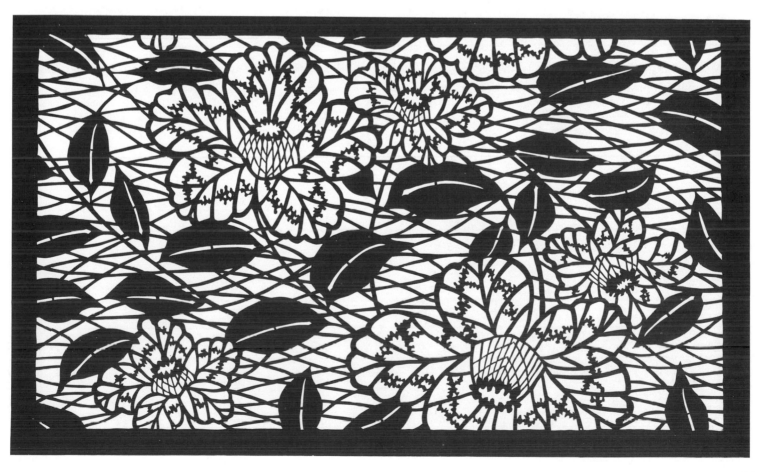

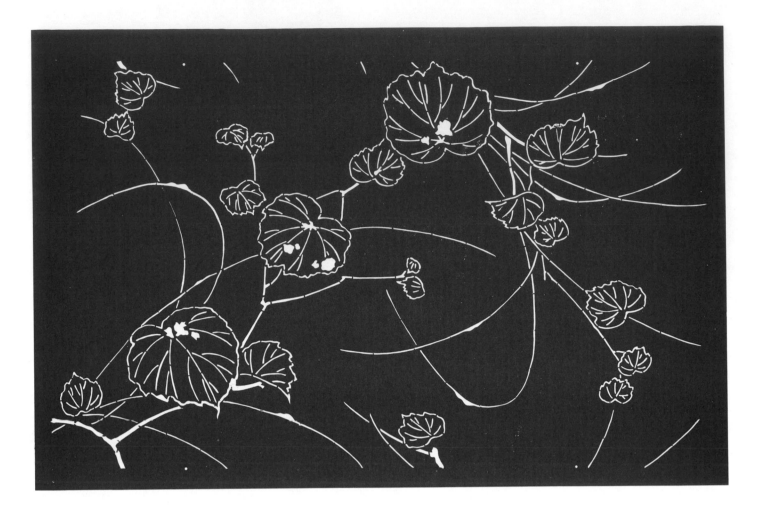

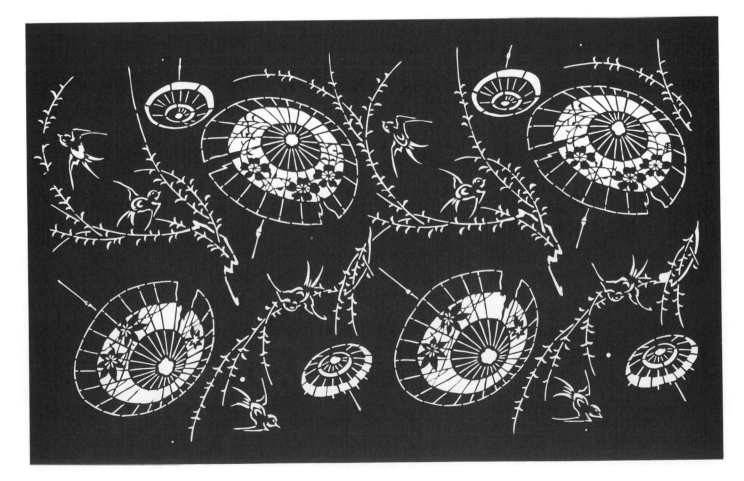

22

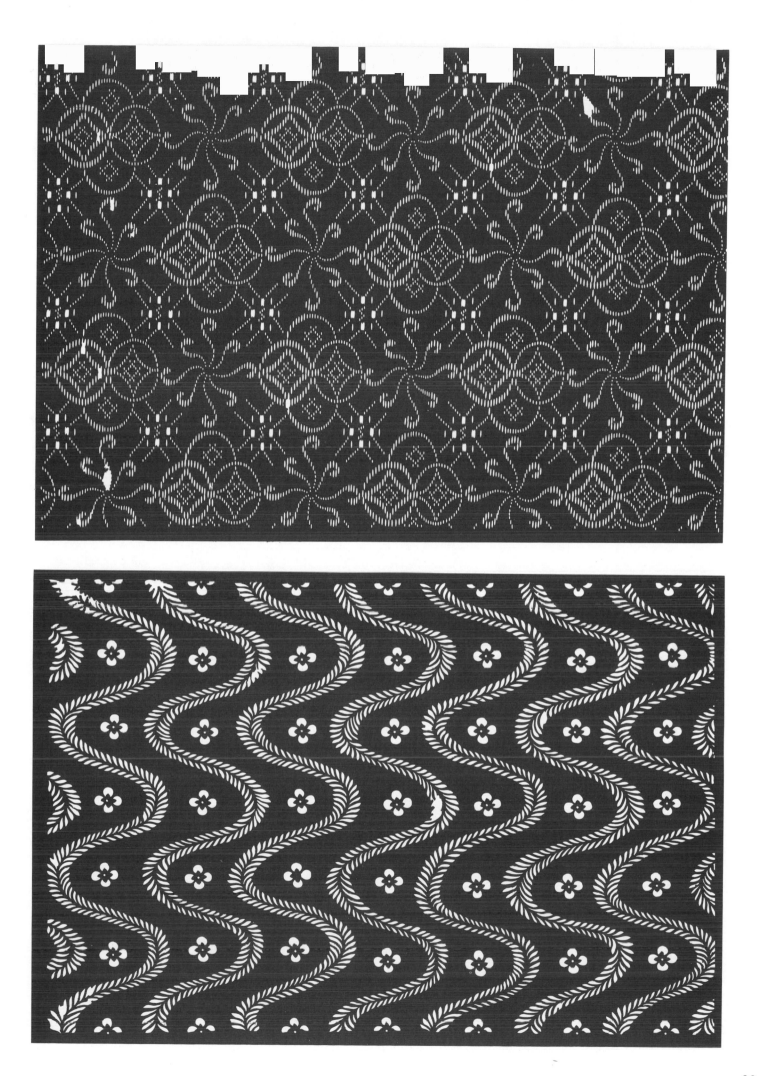

23

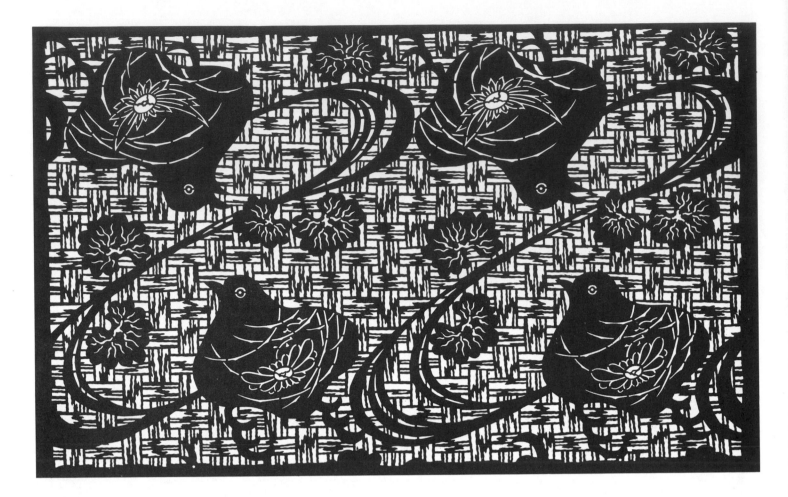

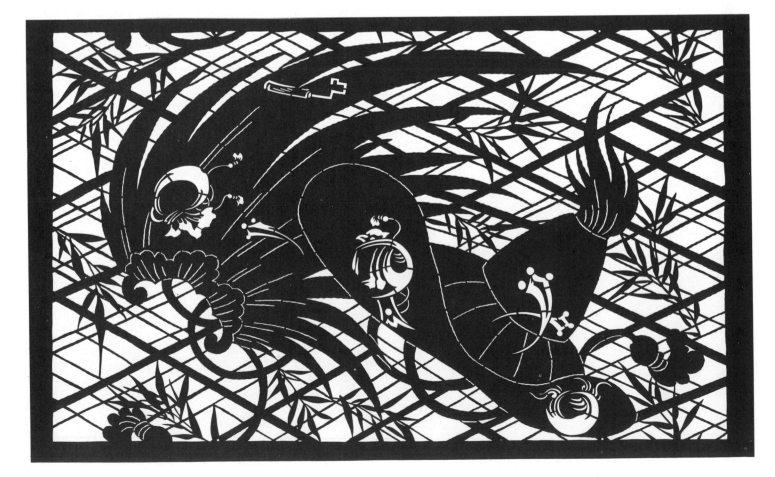

24

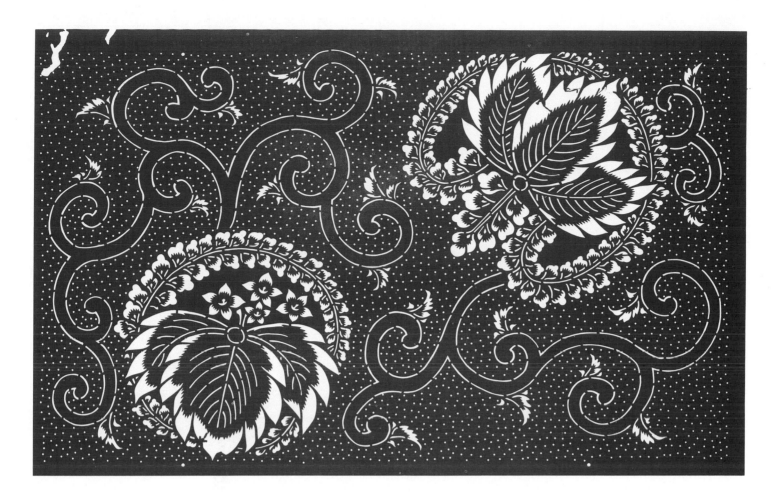

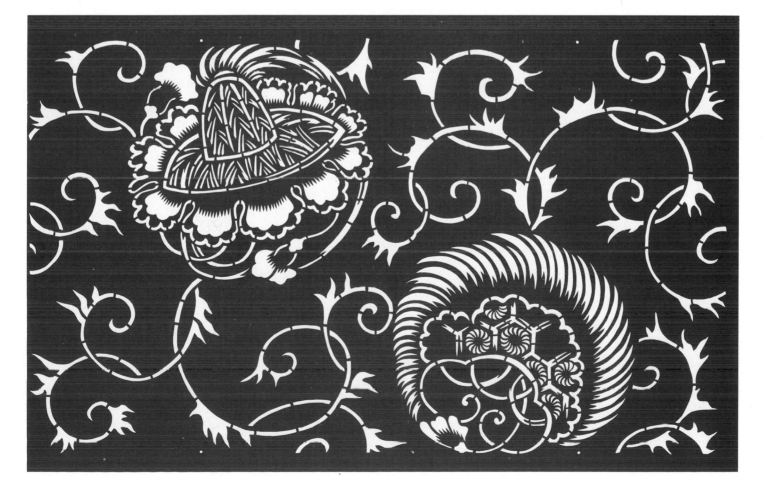

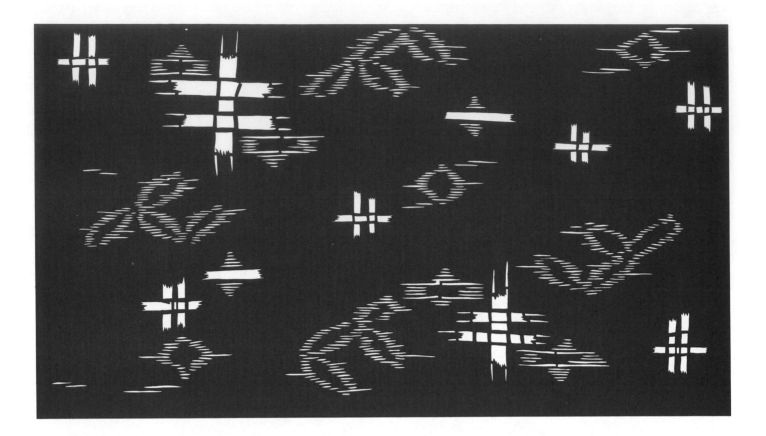

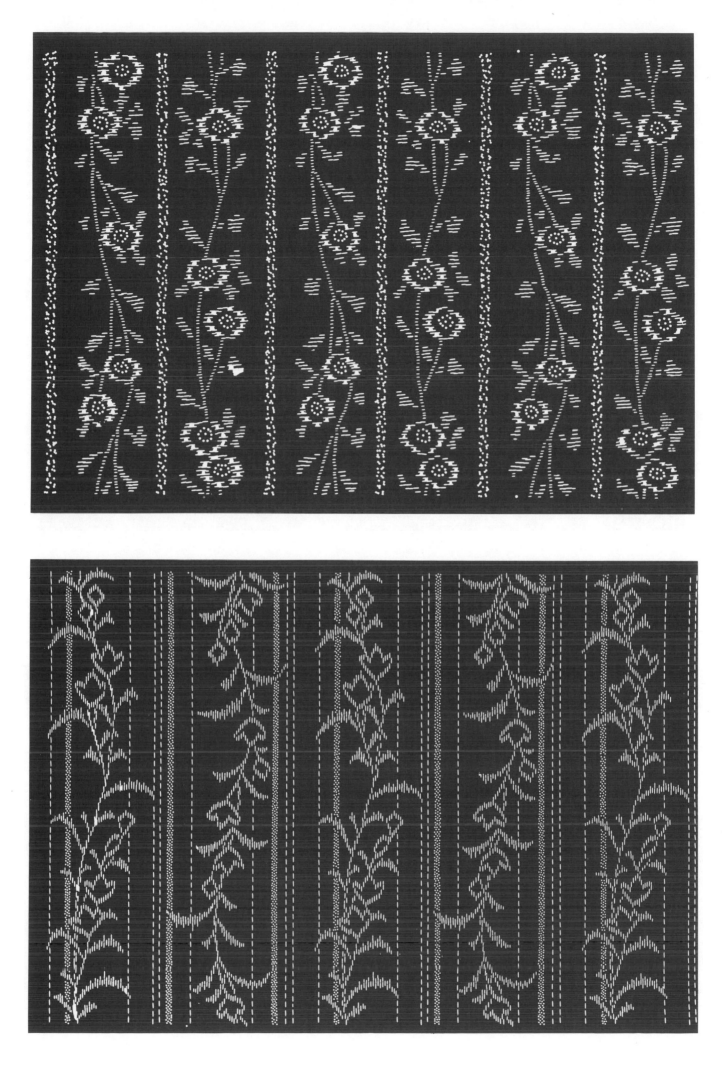

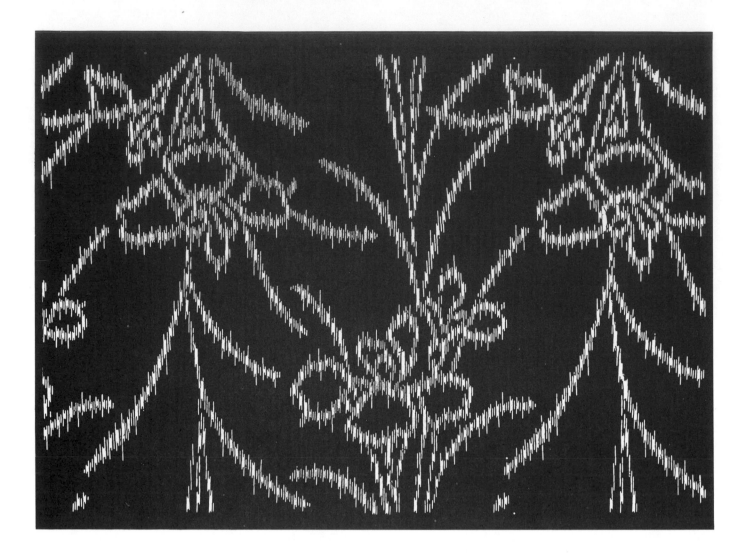

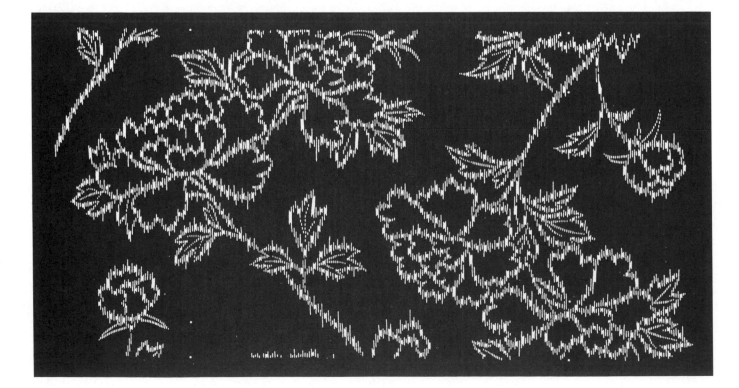

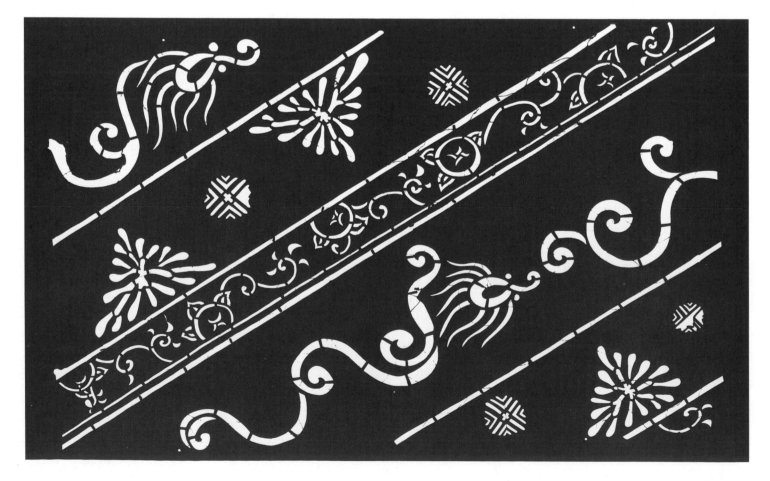

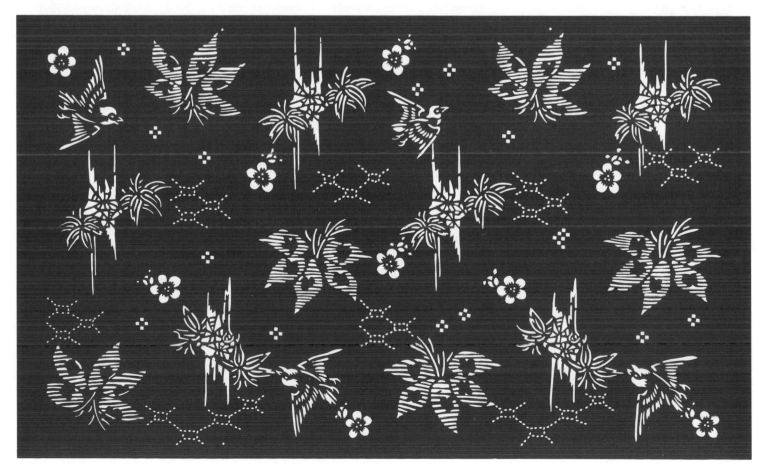

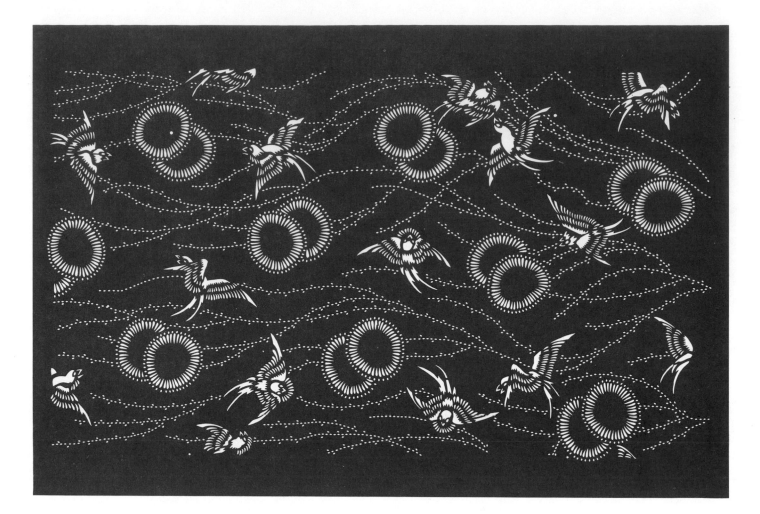

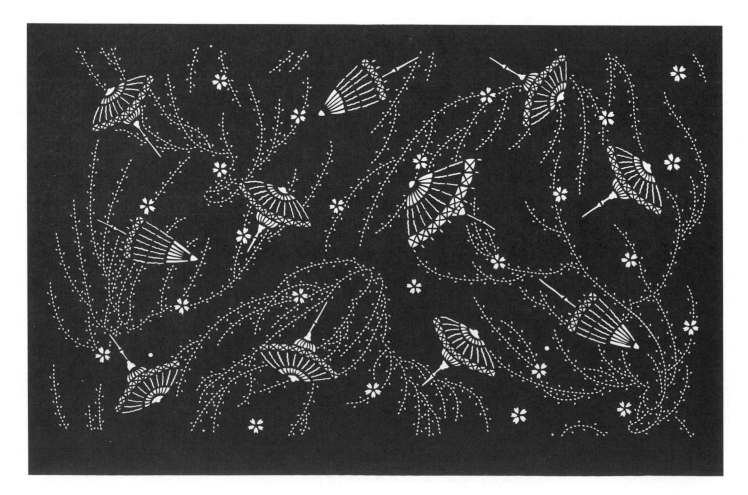

32

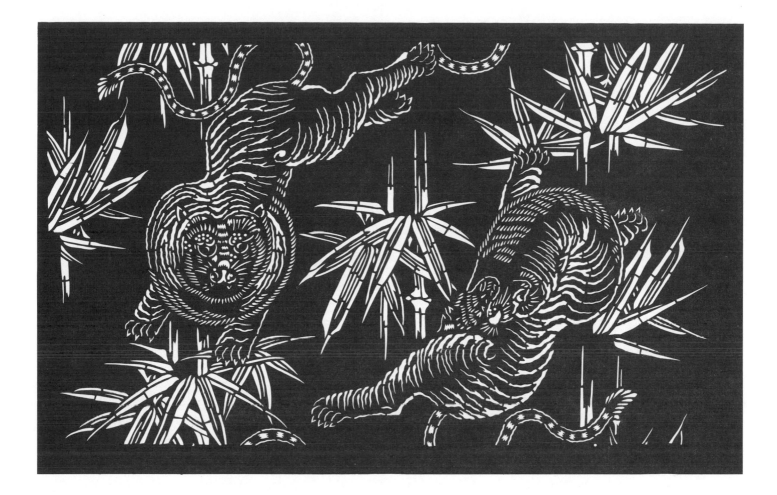

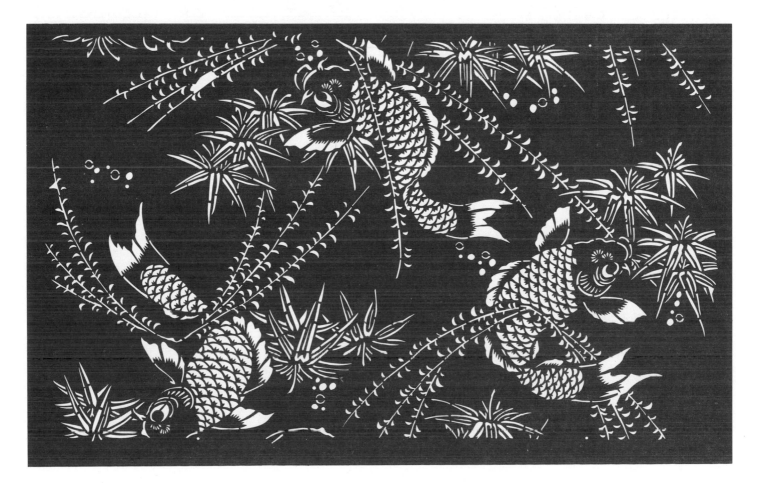

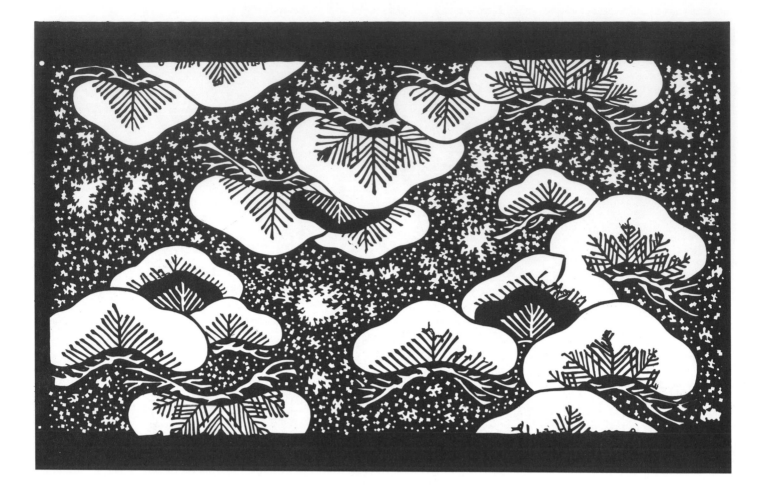

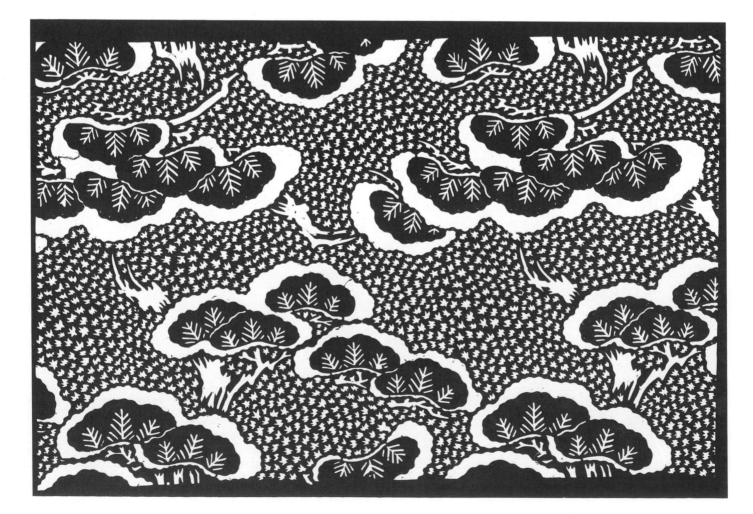

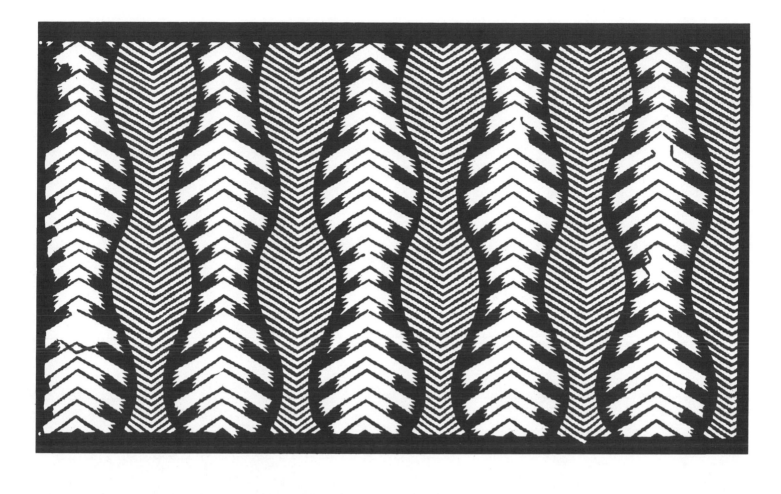

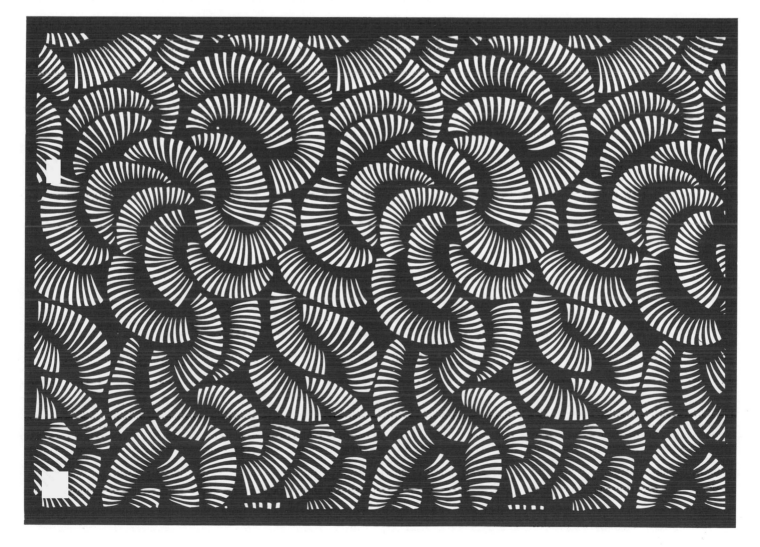

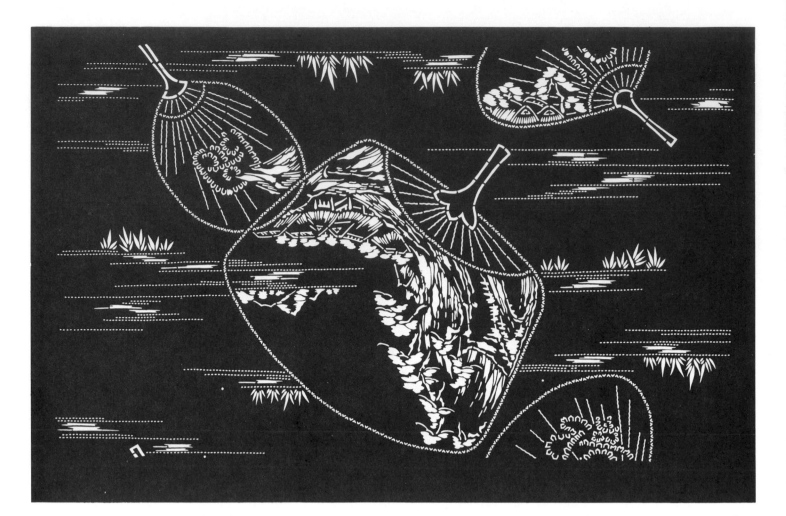

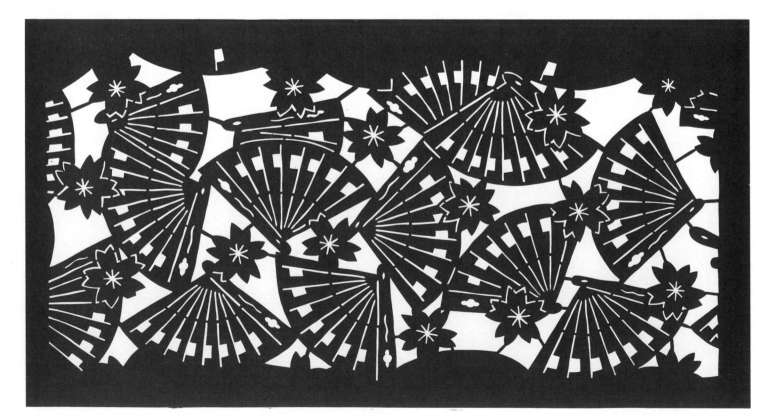

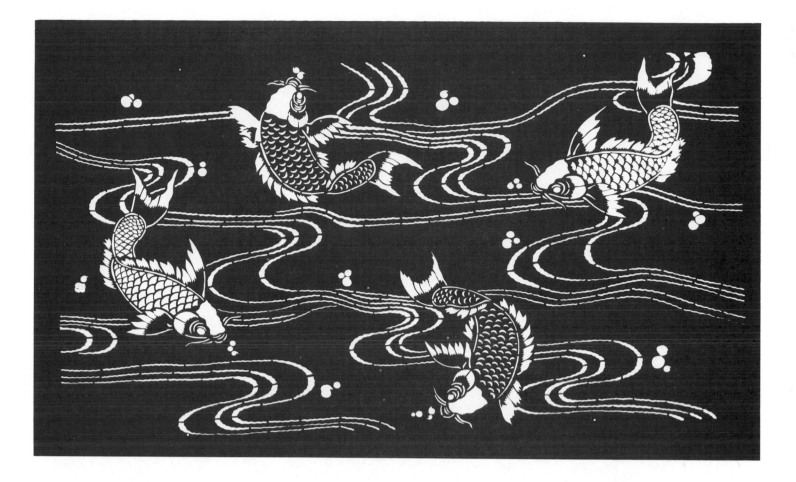

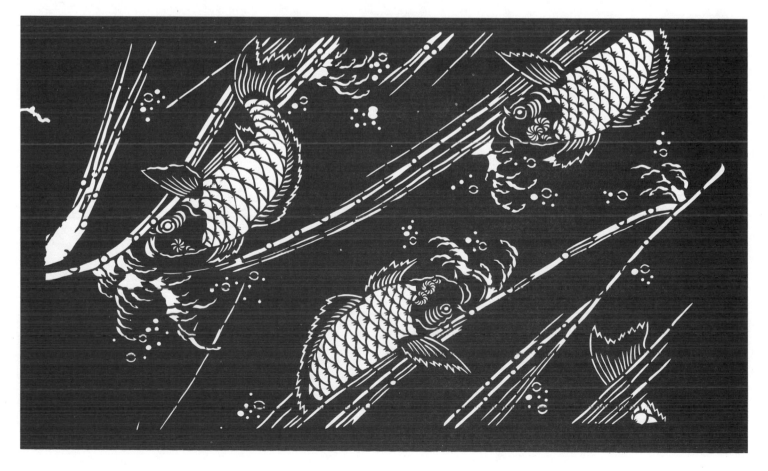

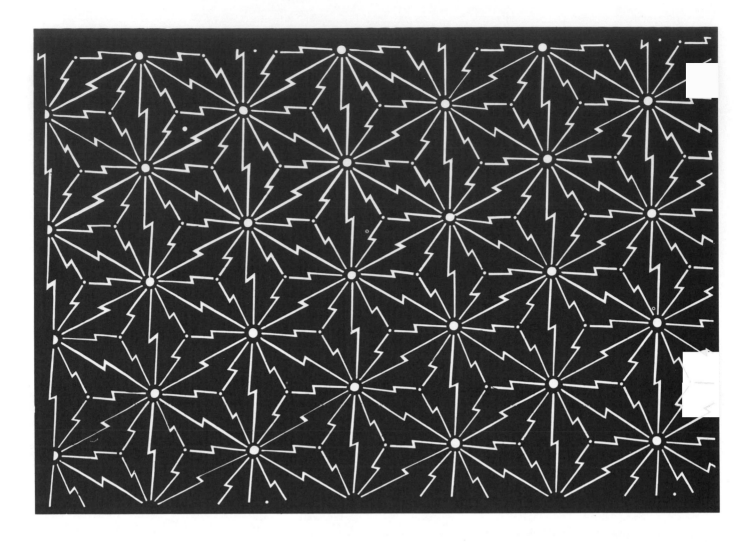

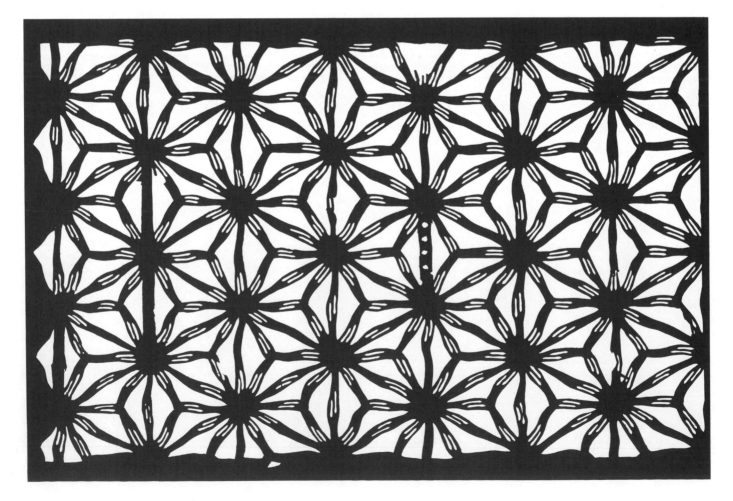

38

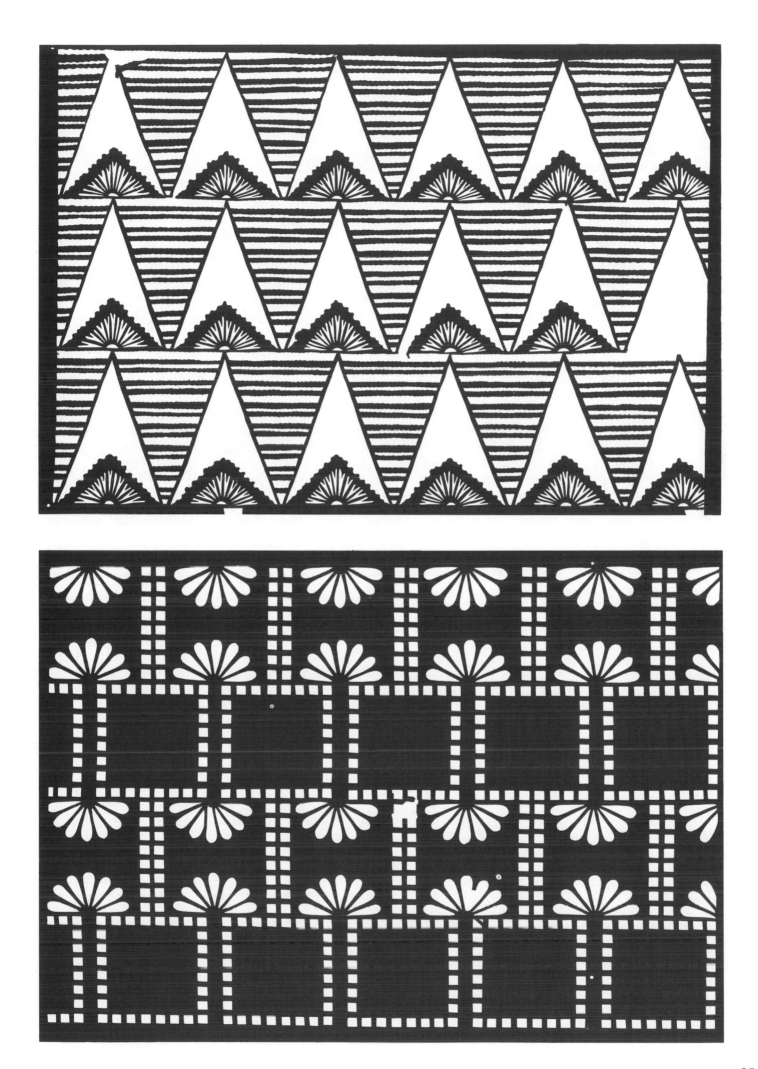

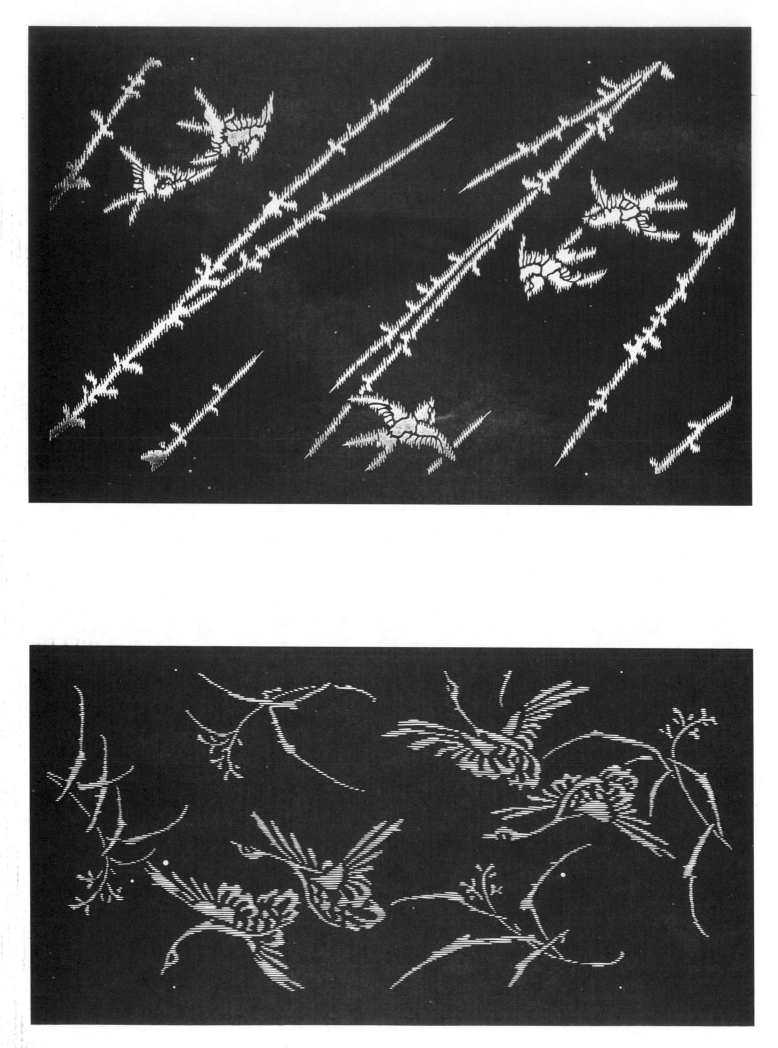

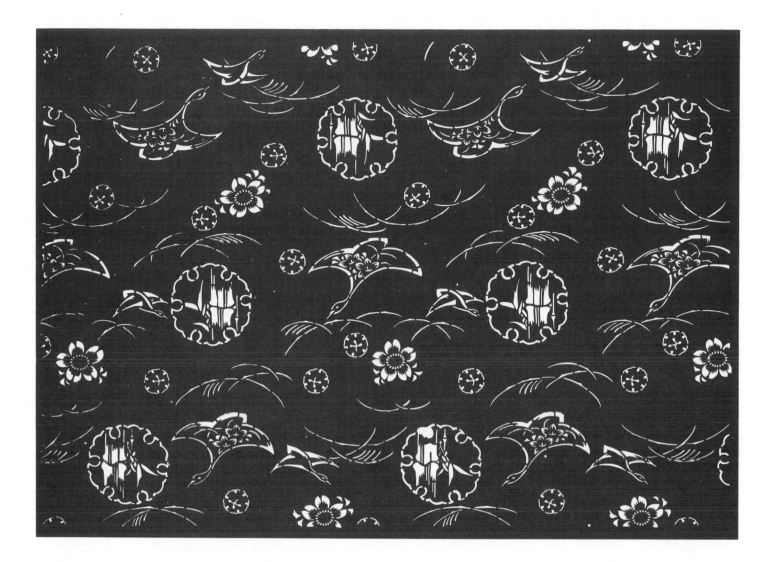

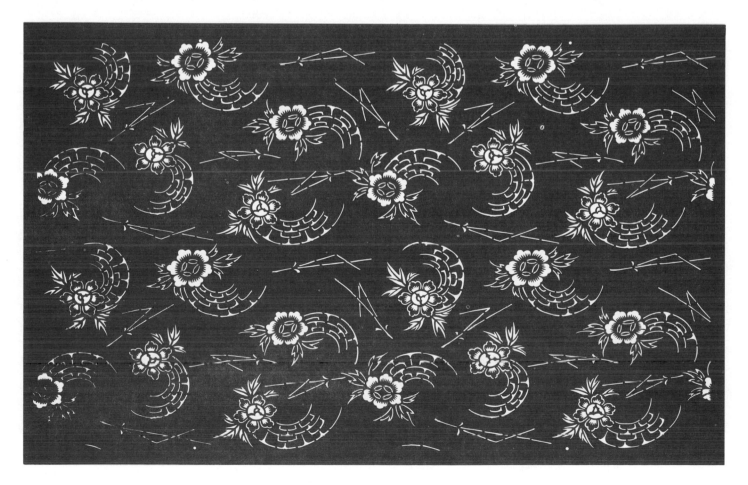

41

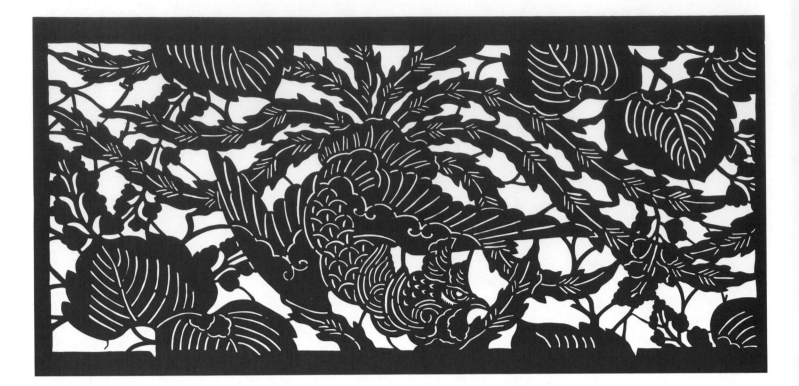

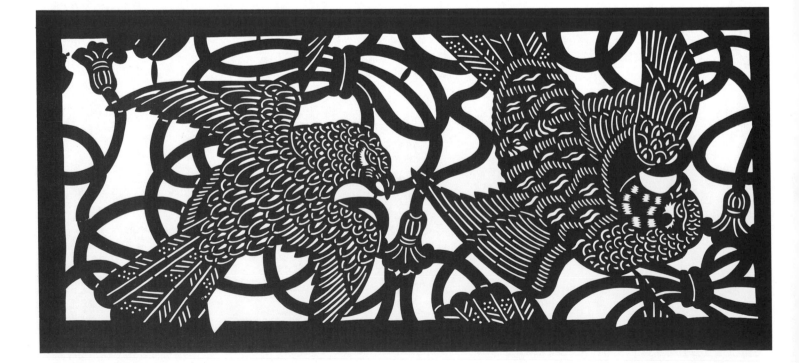

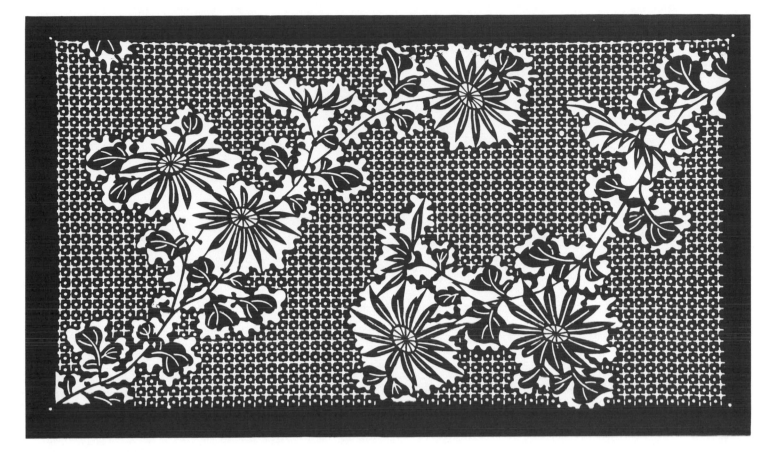

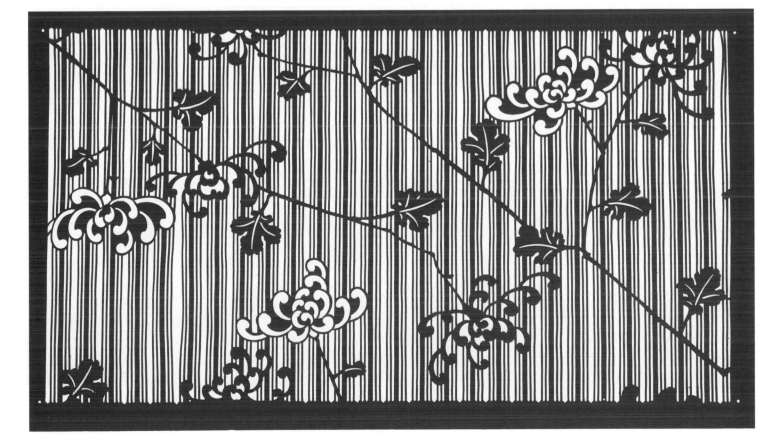

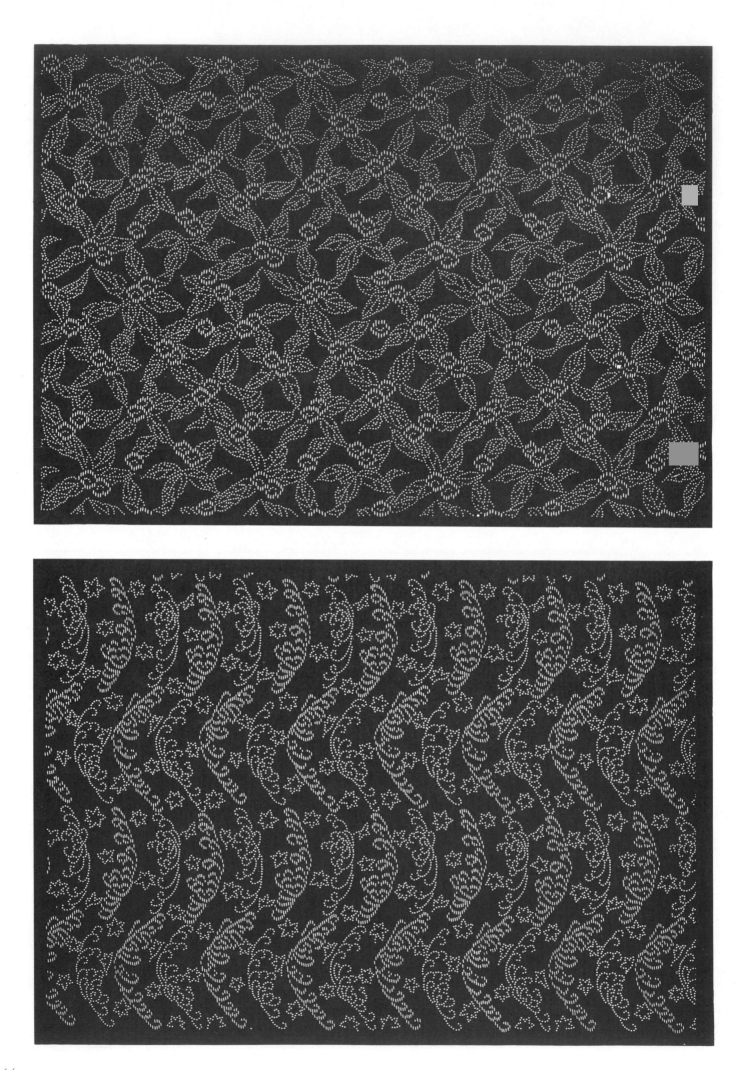

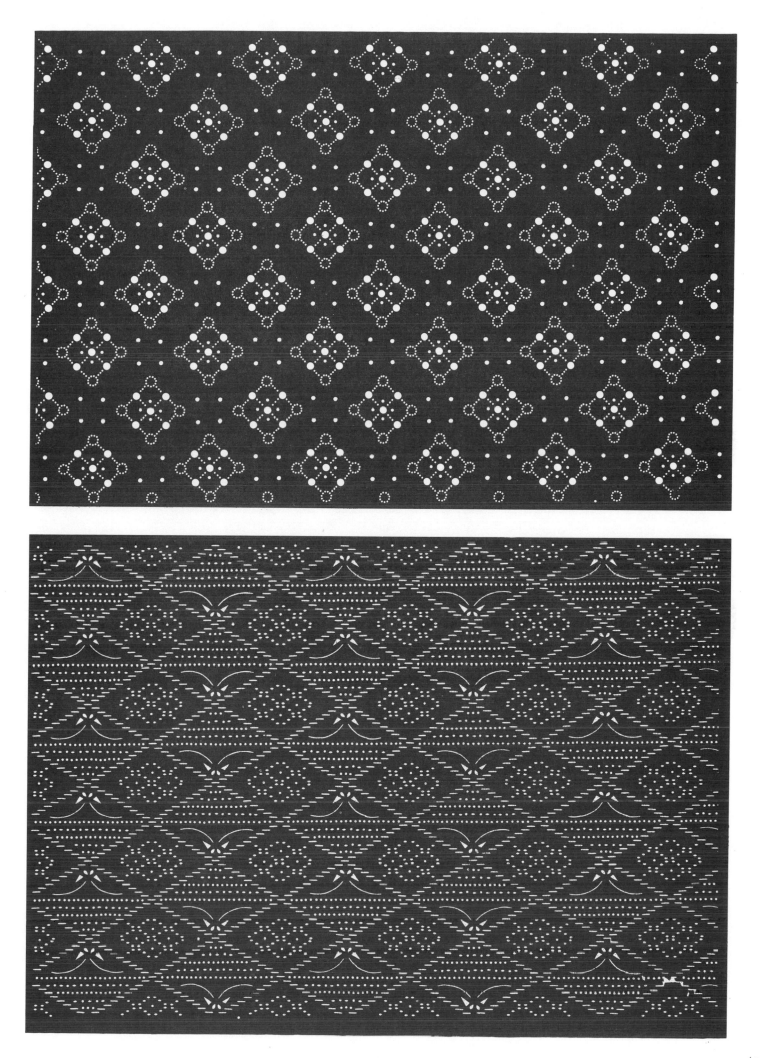

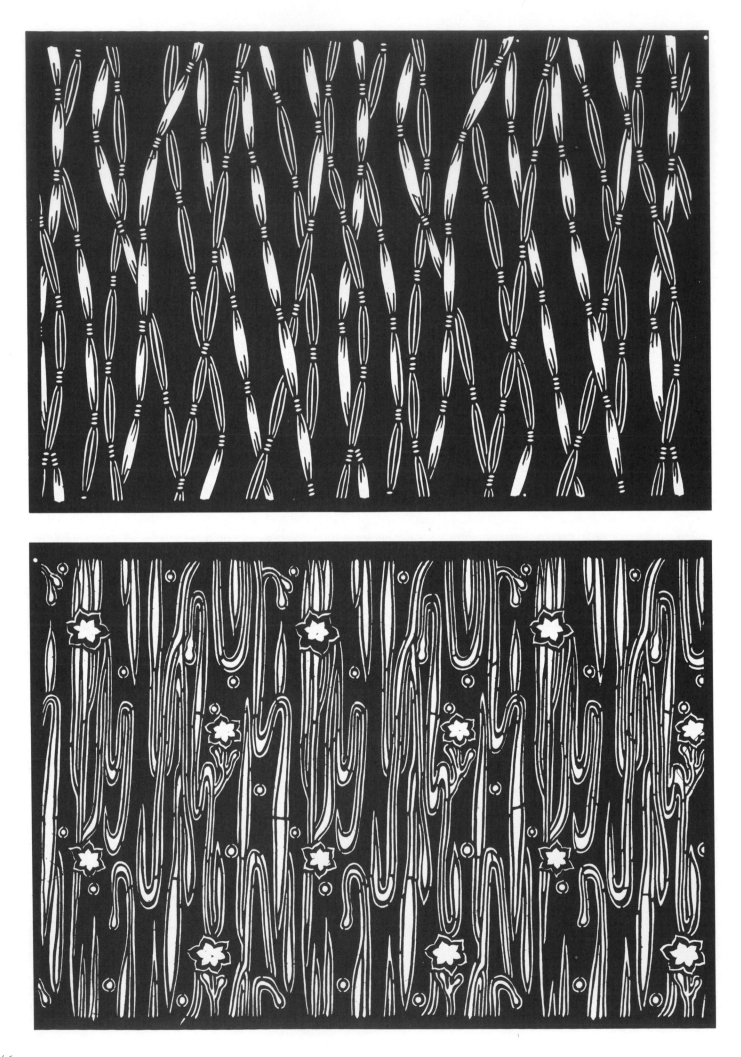

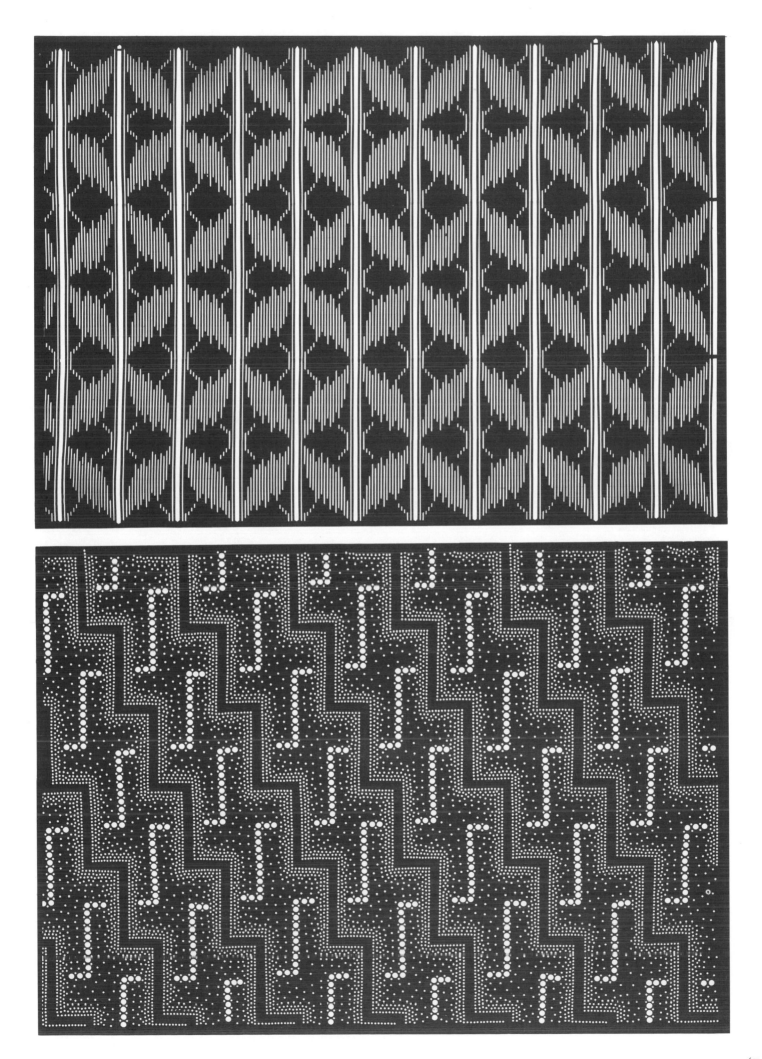

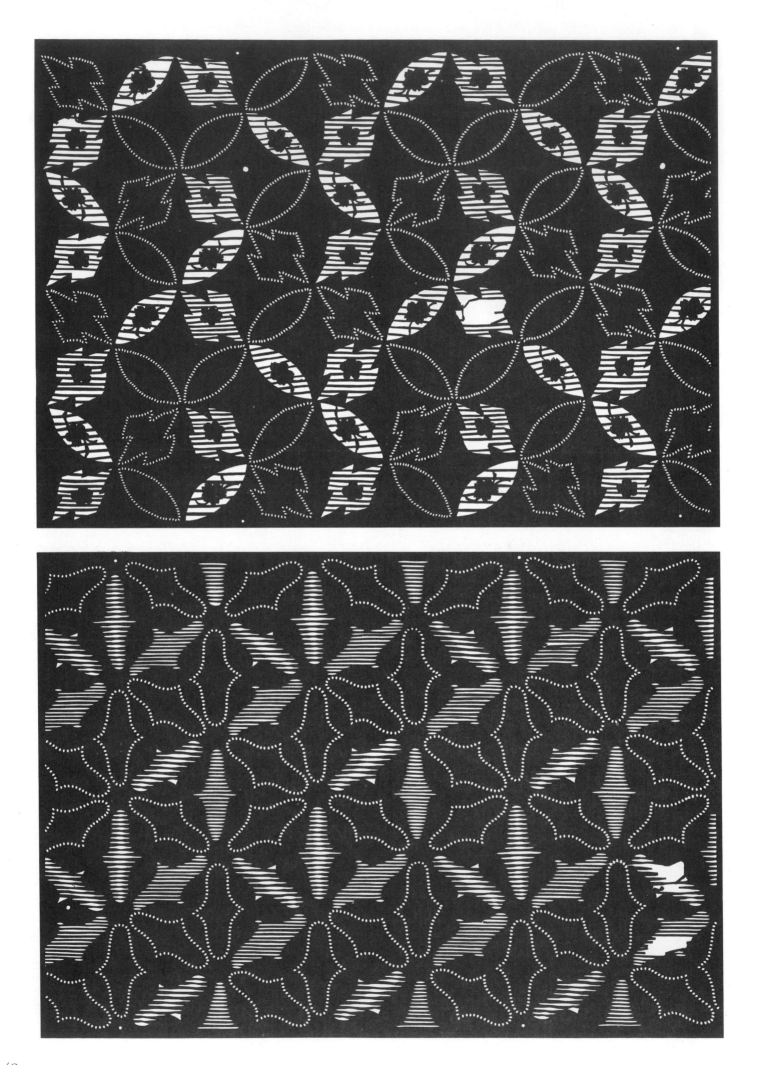

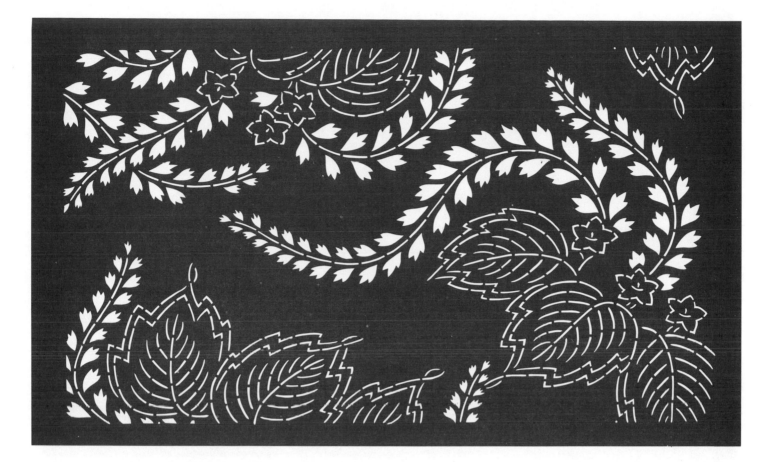

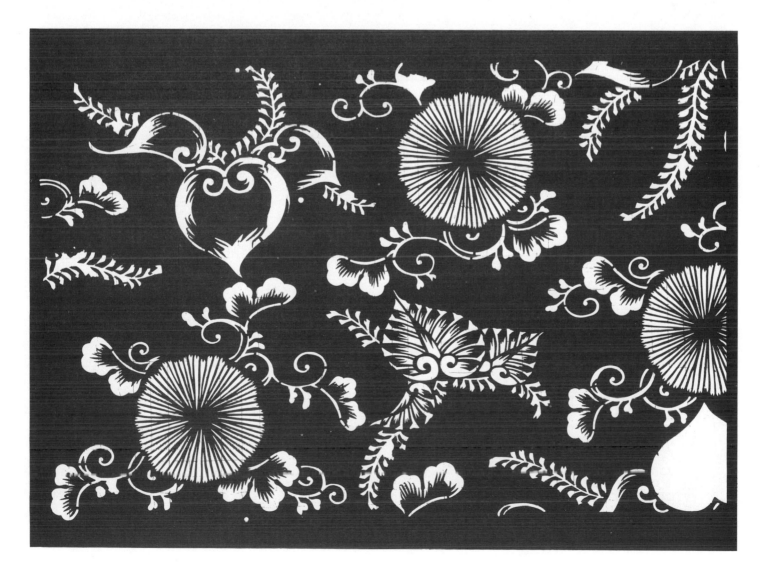

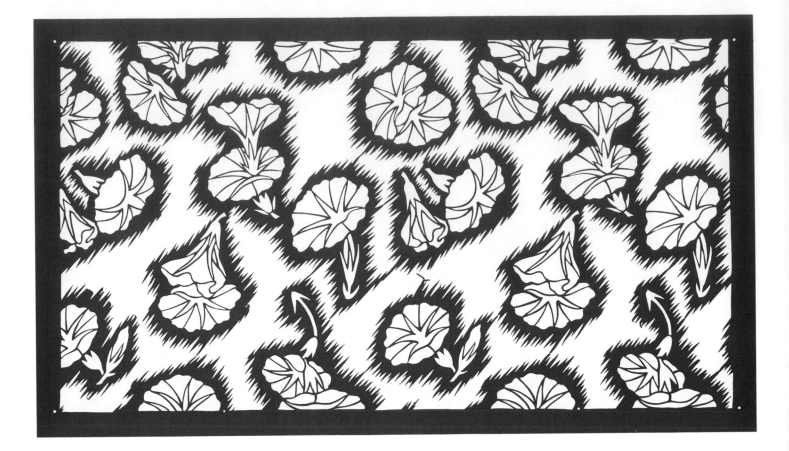

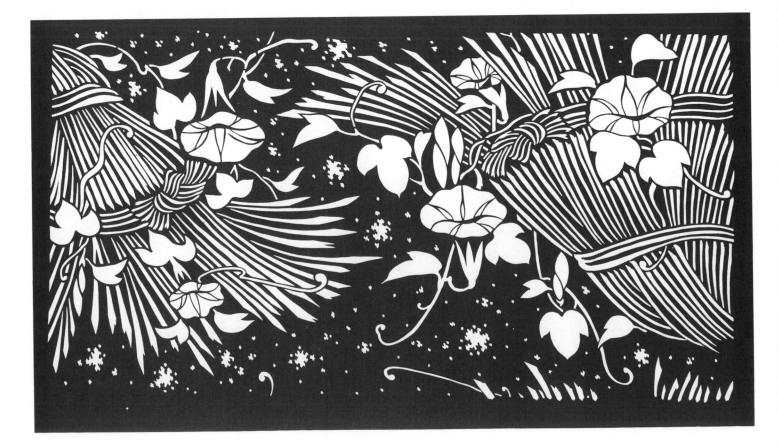

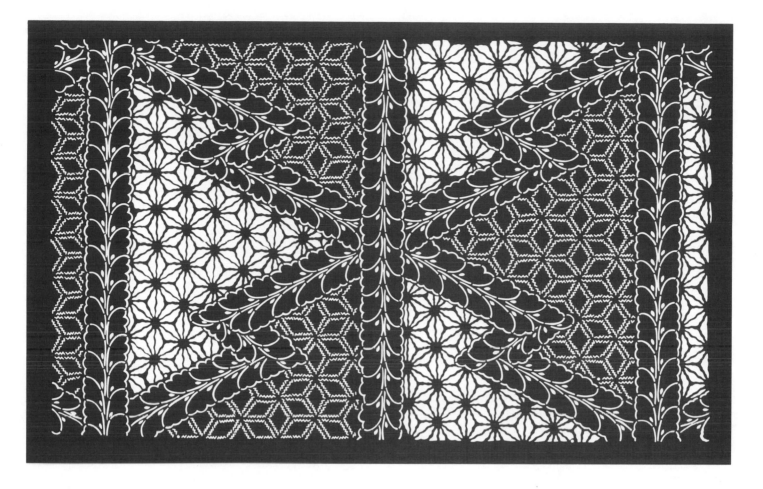

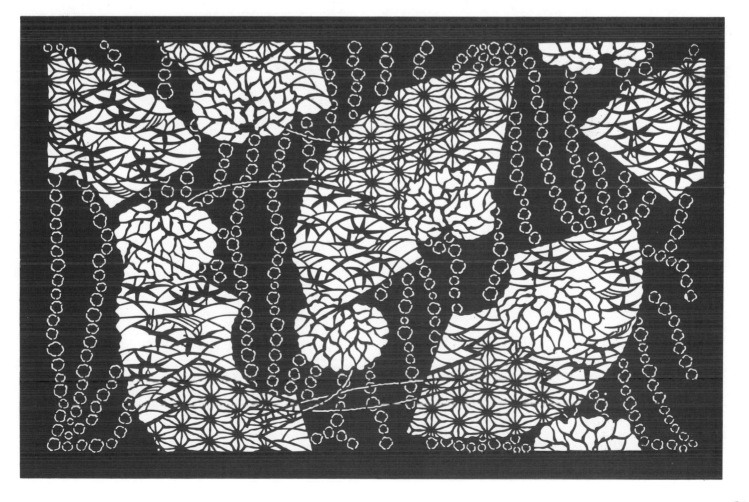

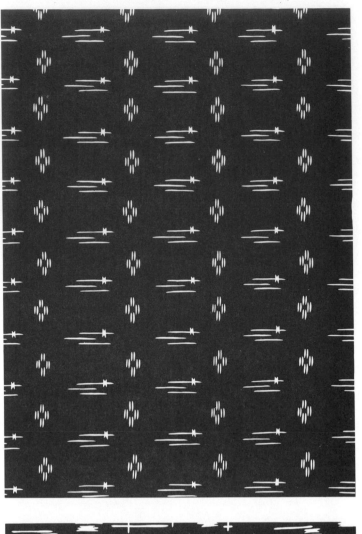
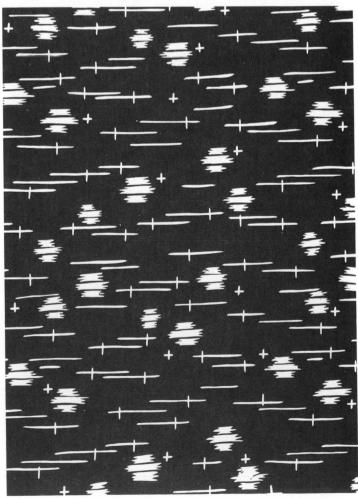

52

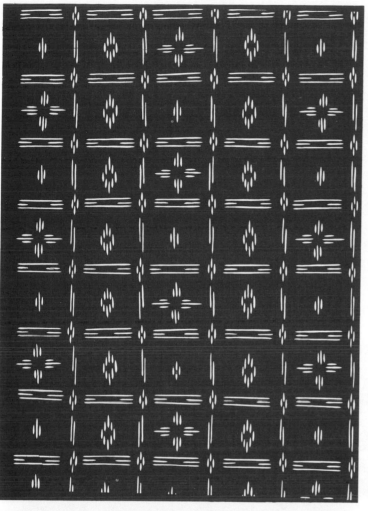
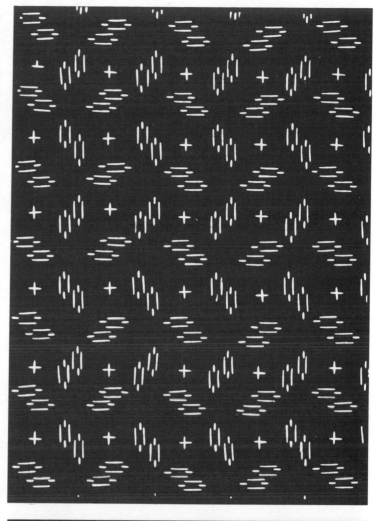

53

54

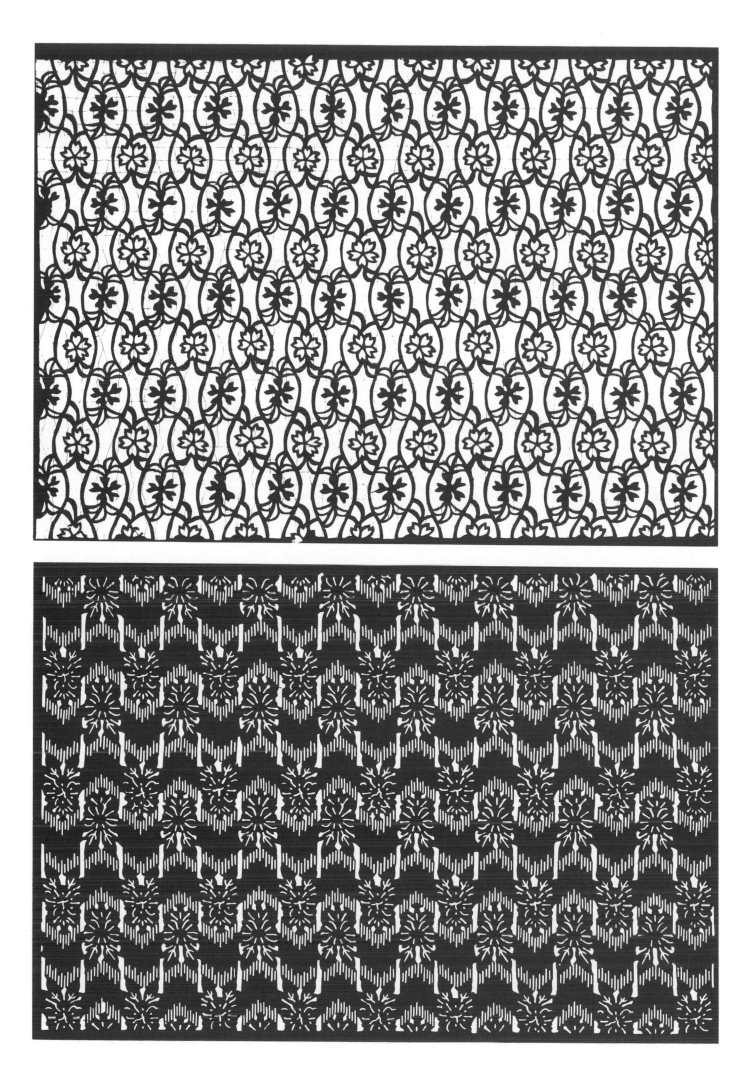

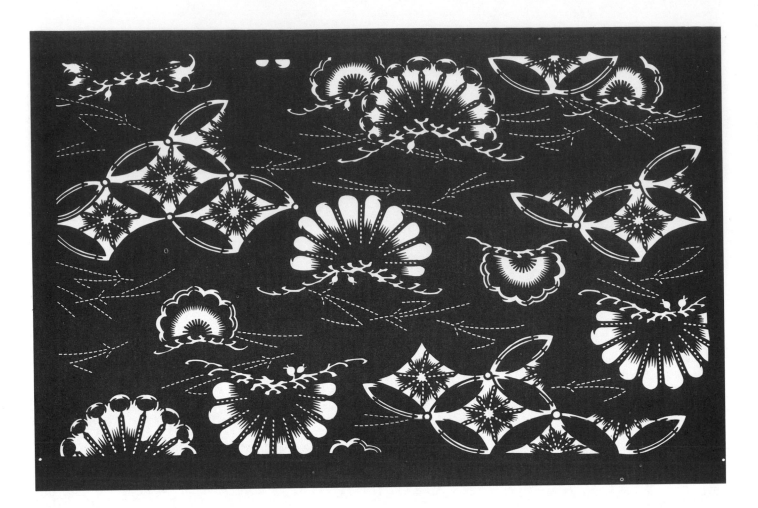

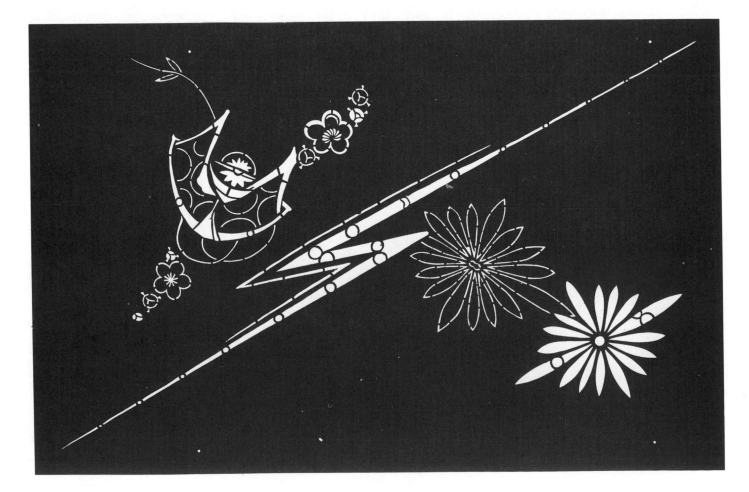

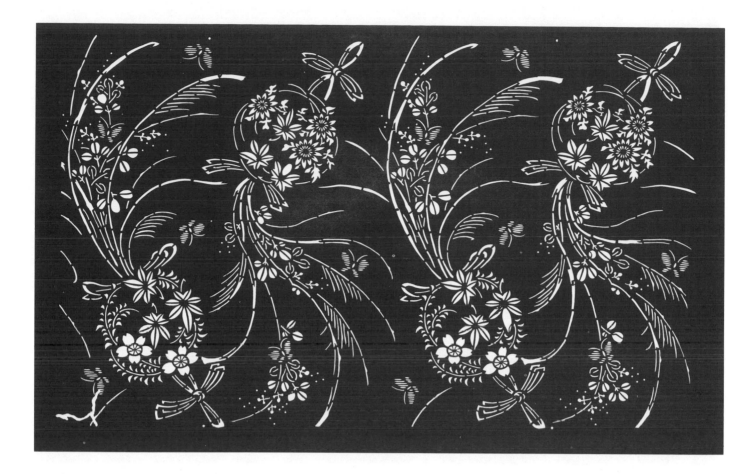

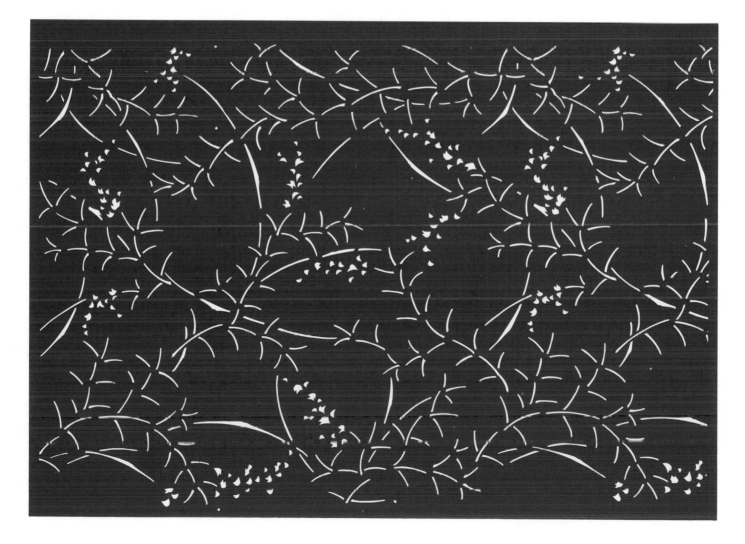

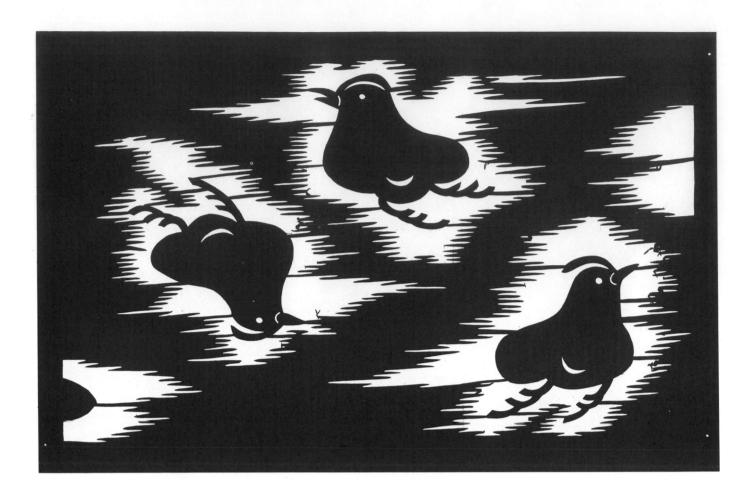

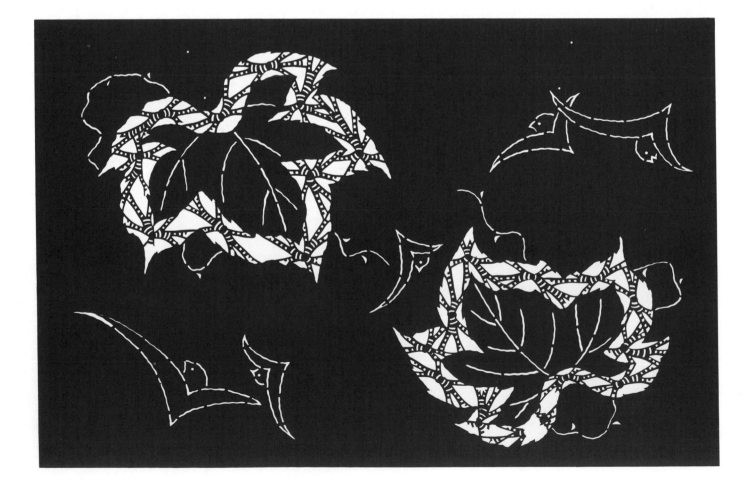

58

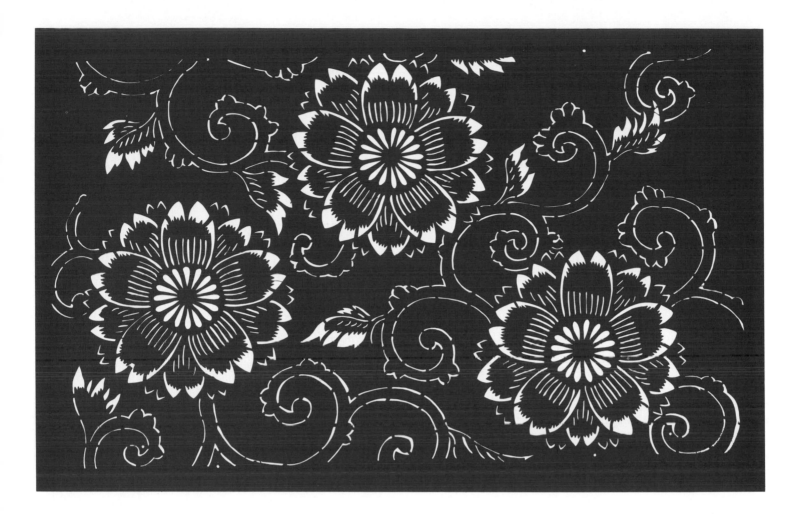

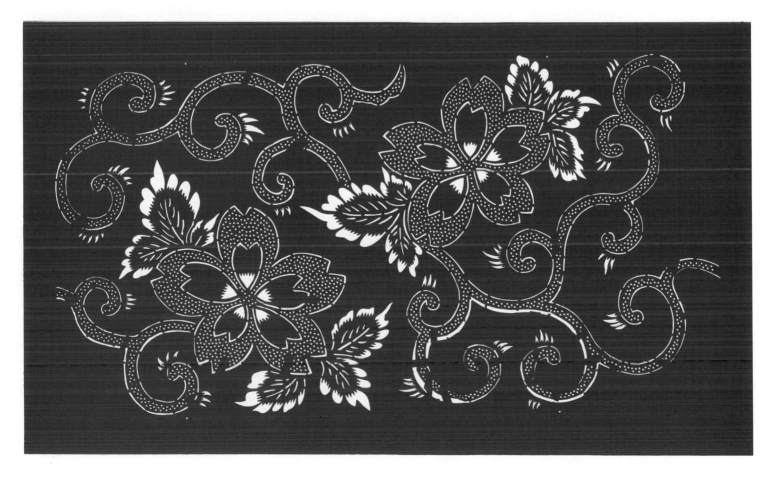

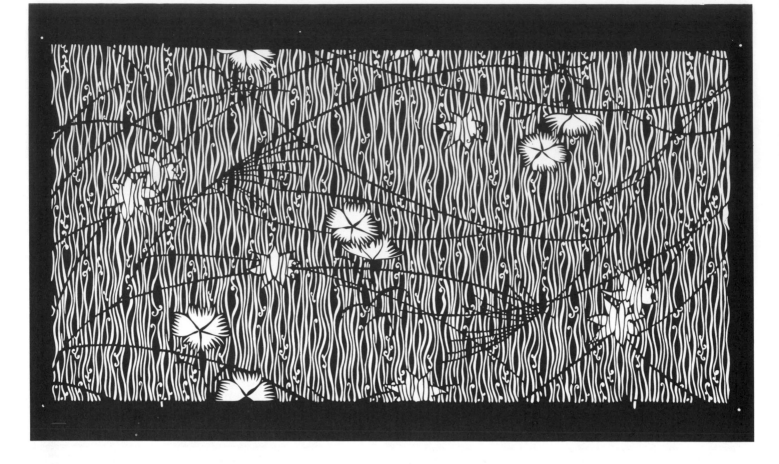

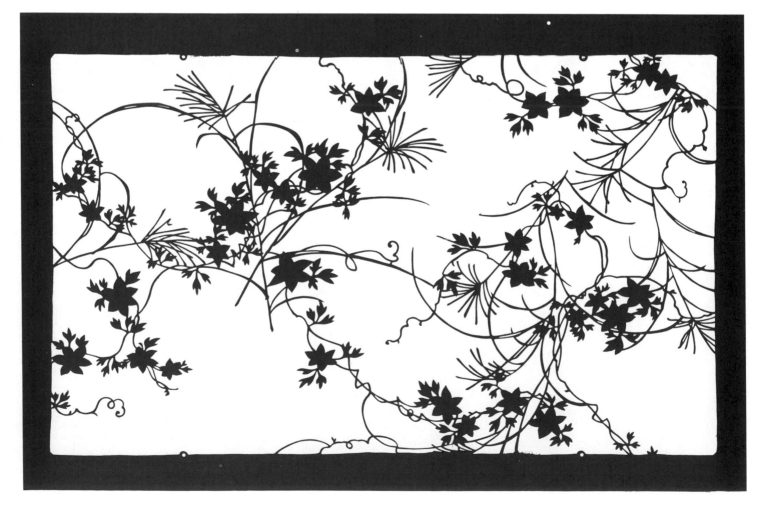

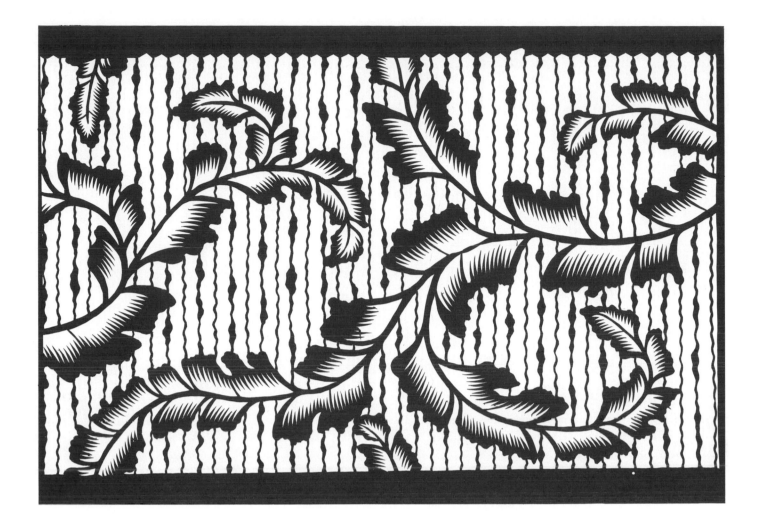

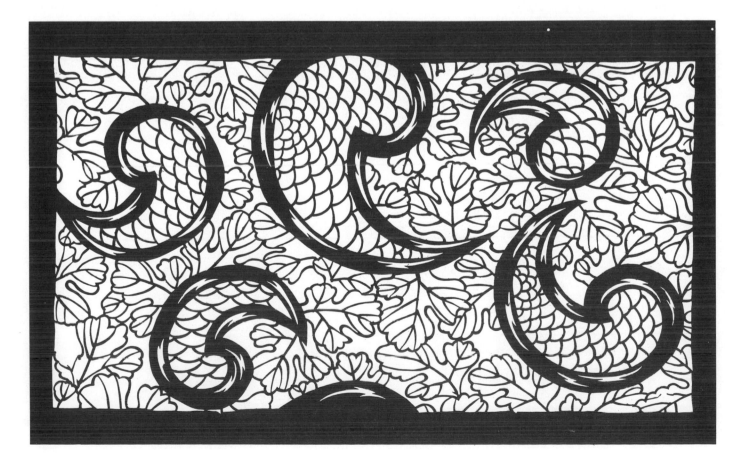

61

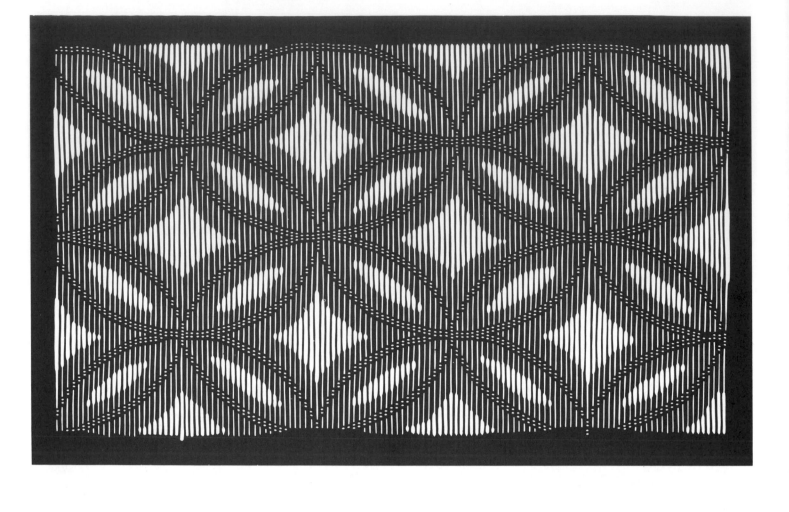

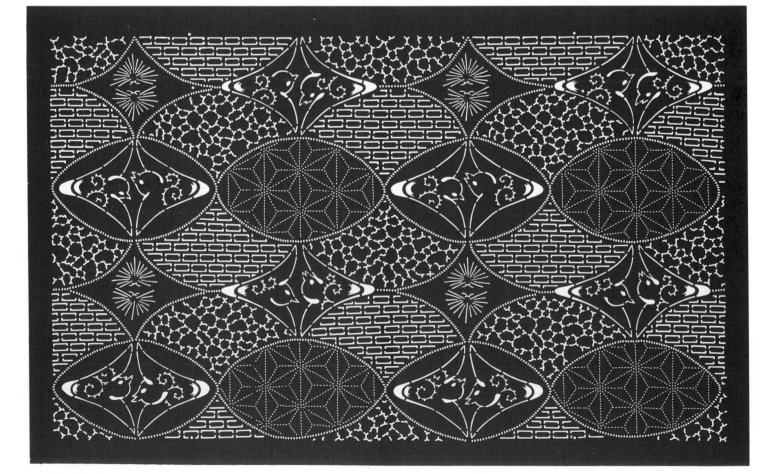

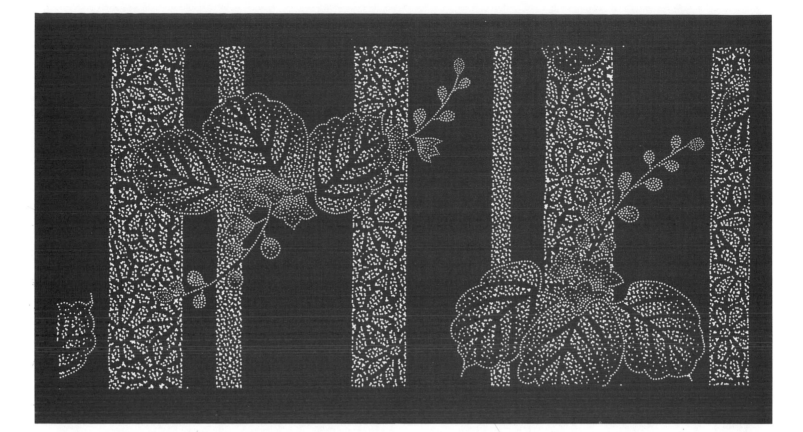

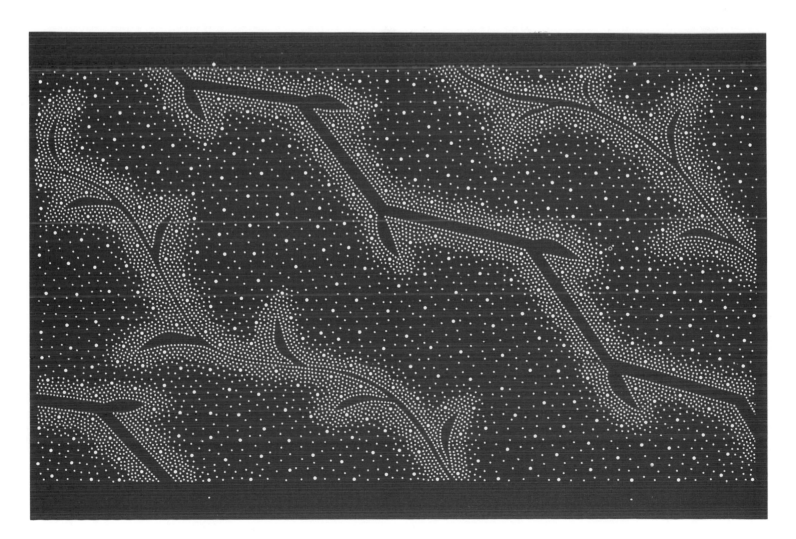

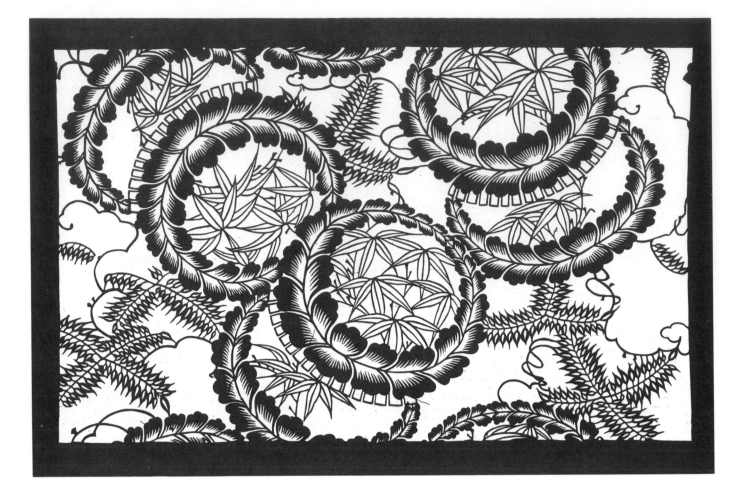

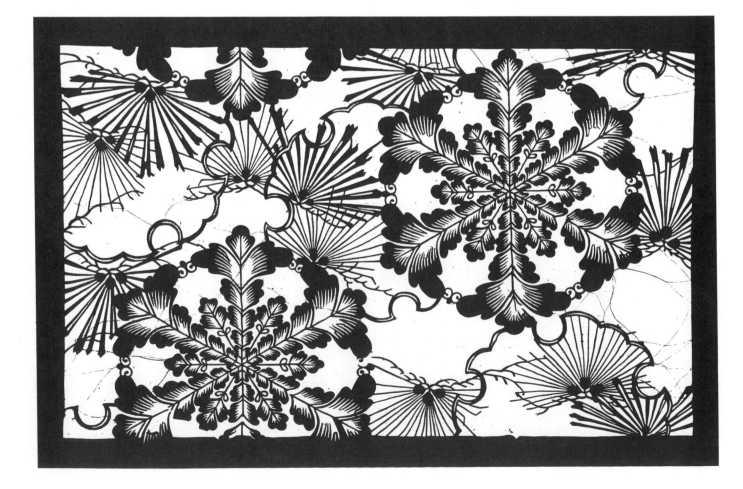

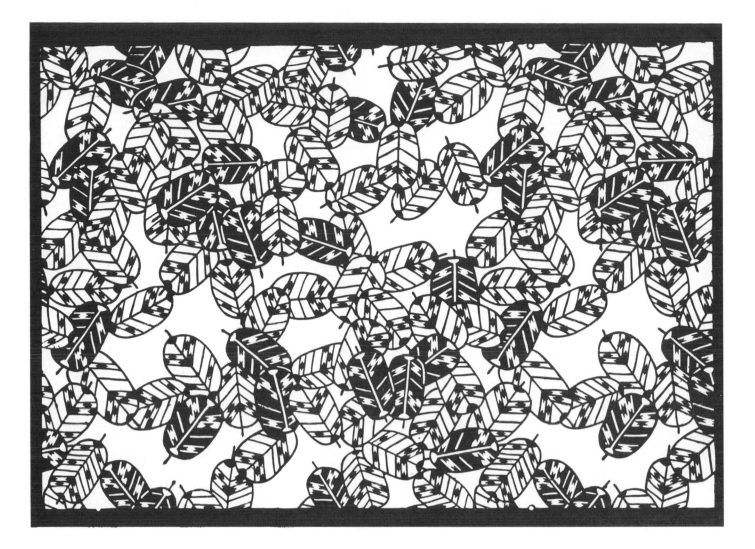

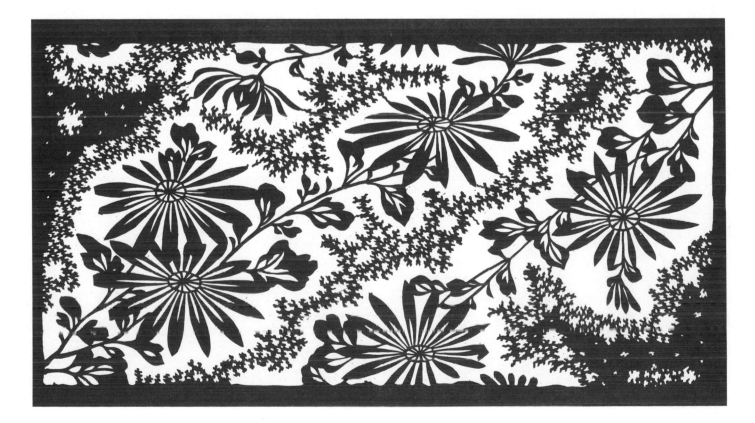

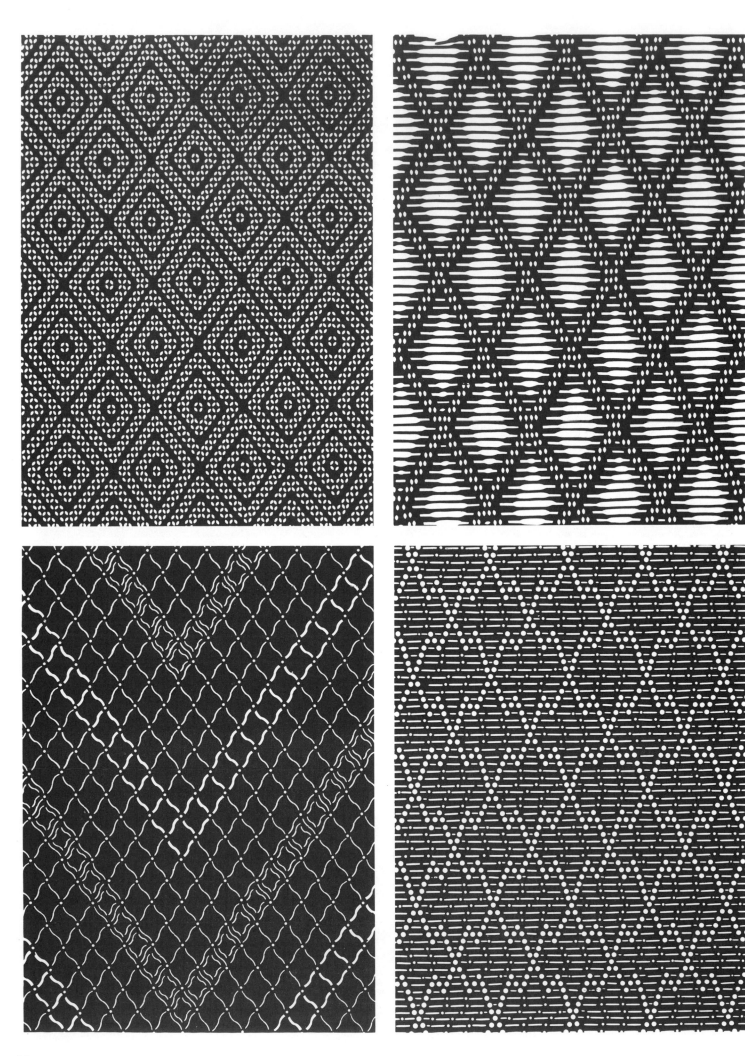

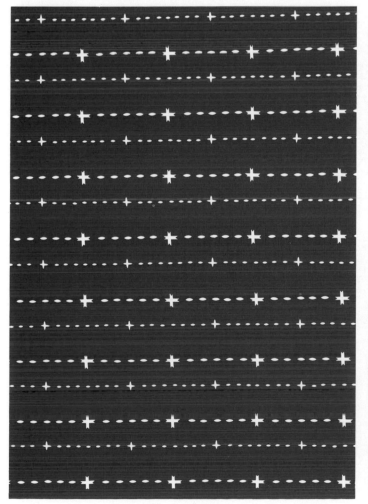
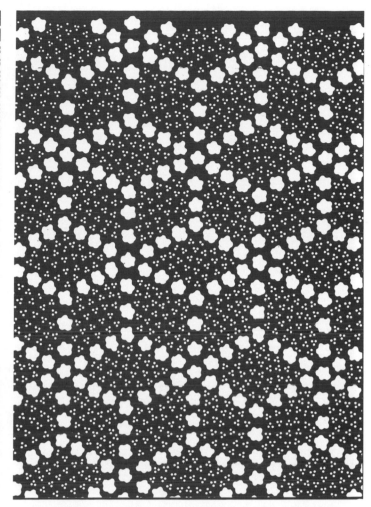
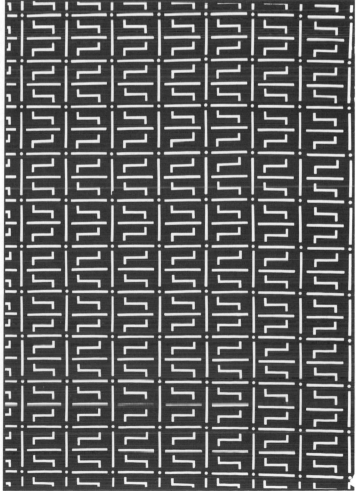

67

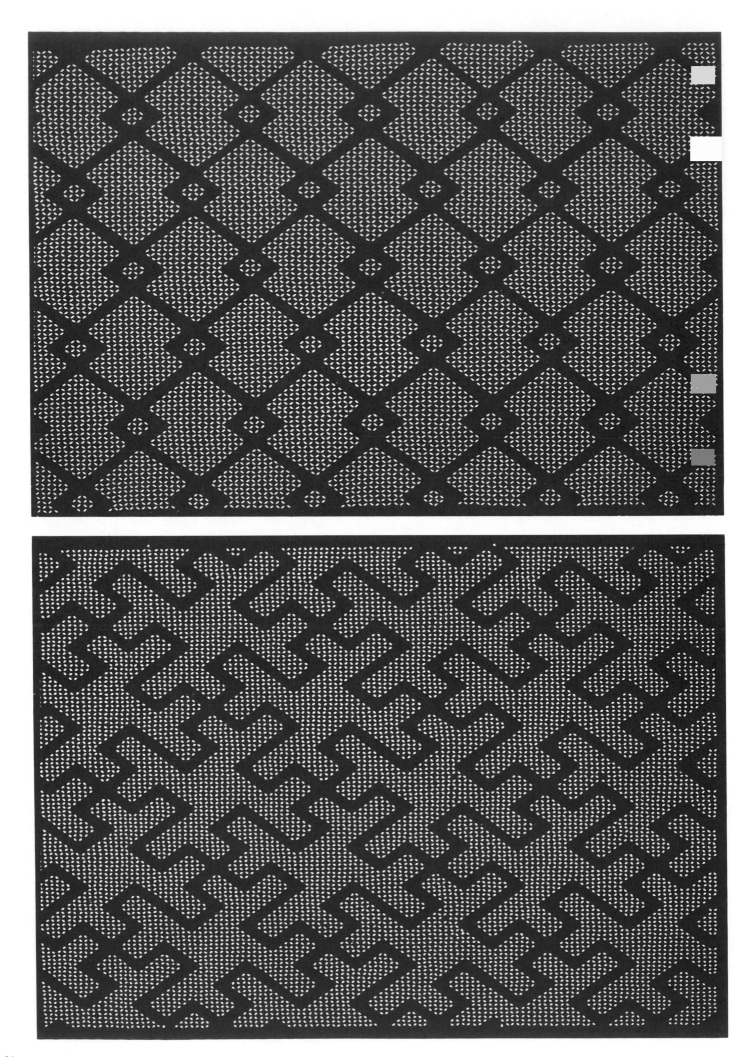

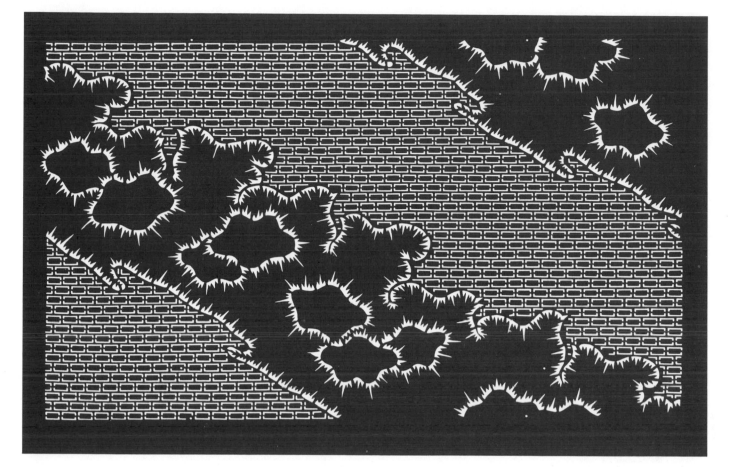

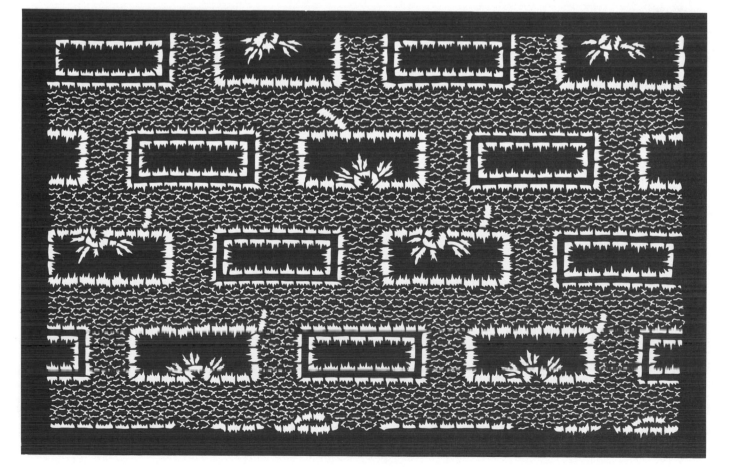

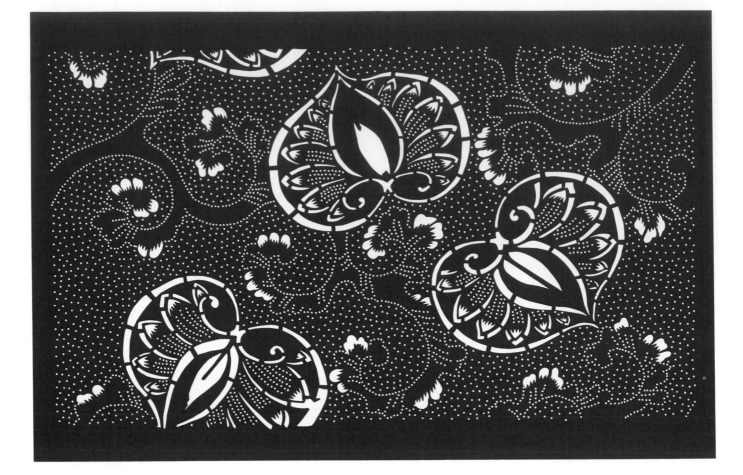

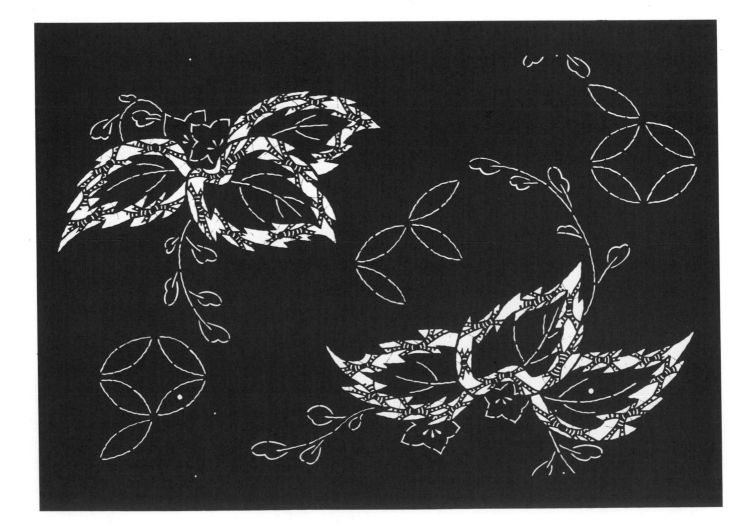

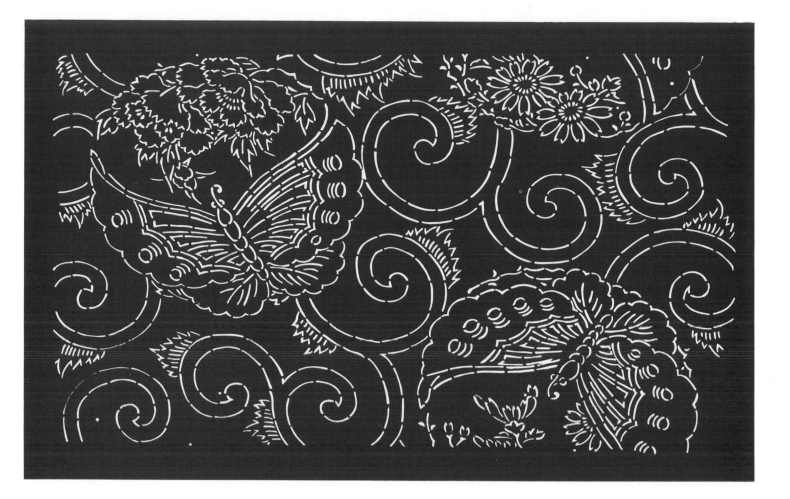

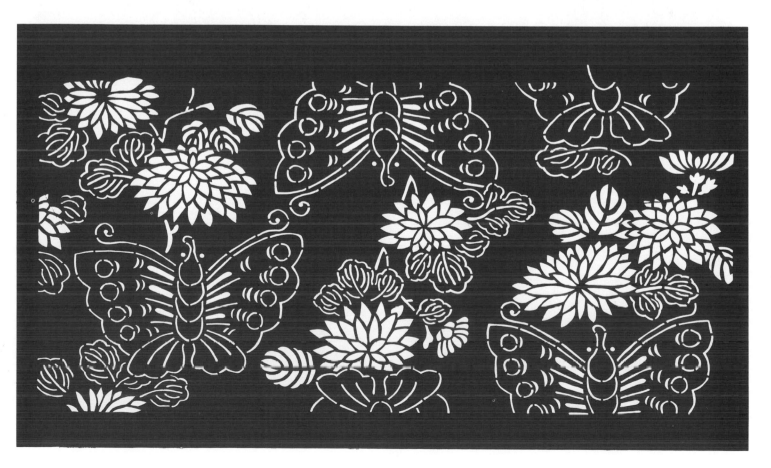

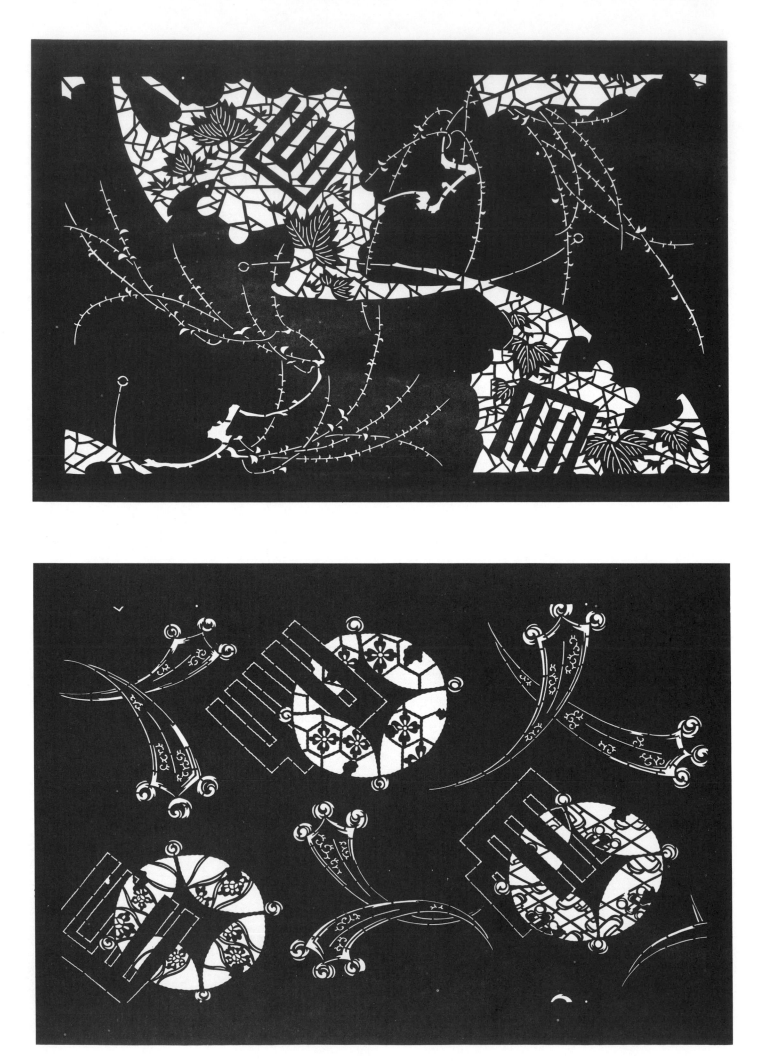

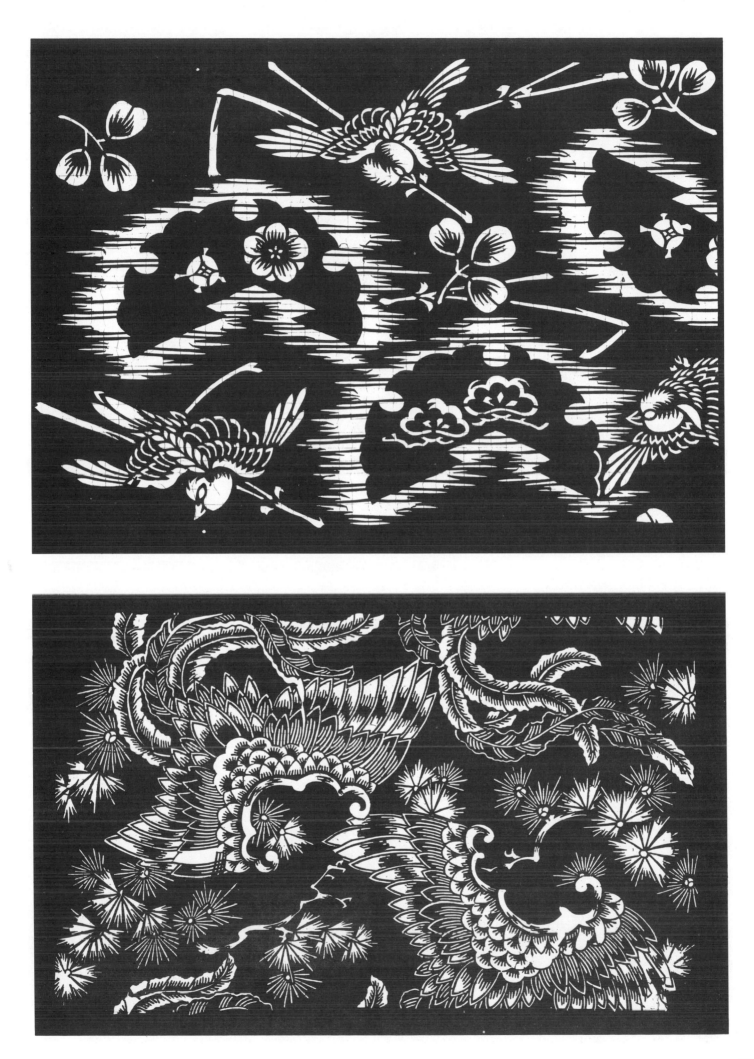

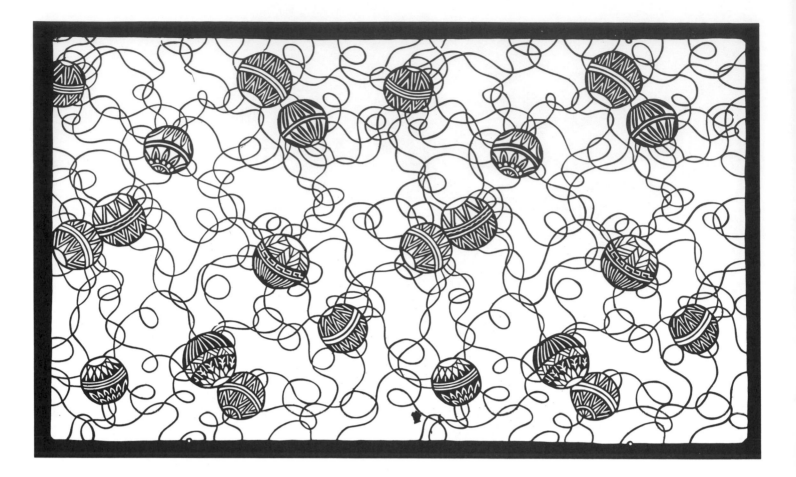

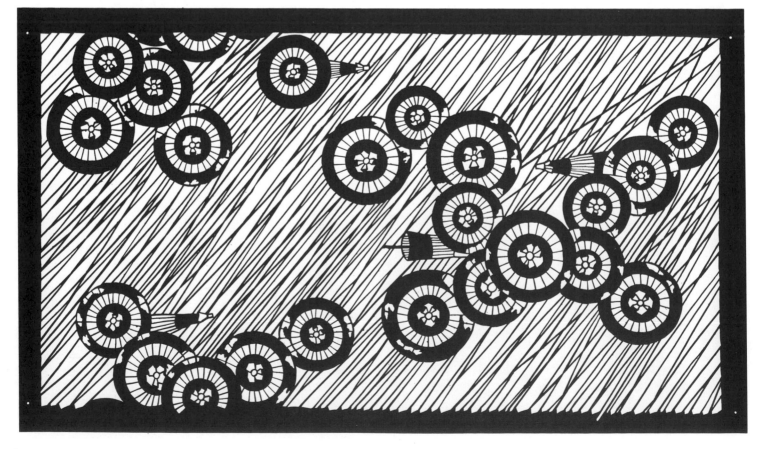

74

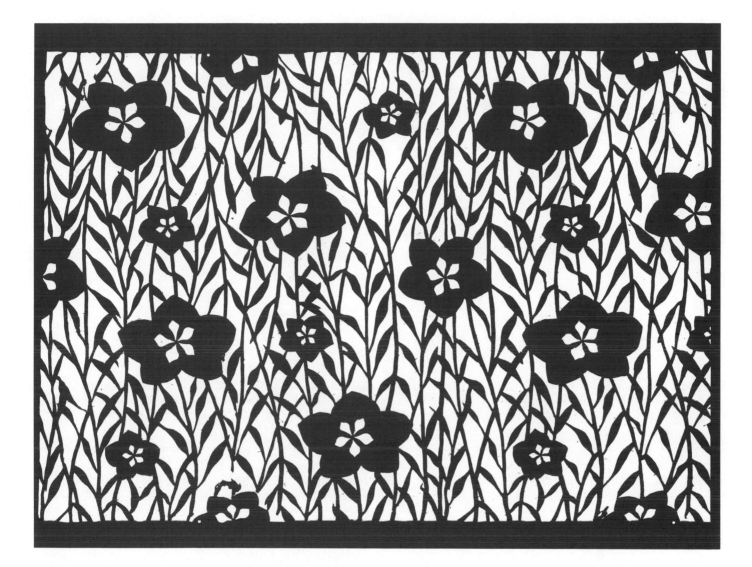

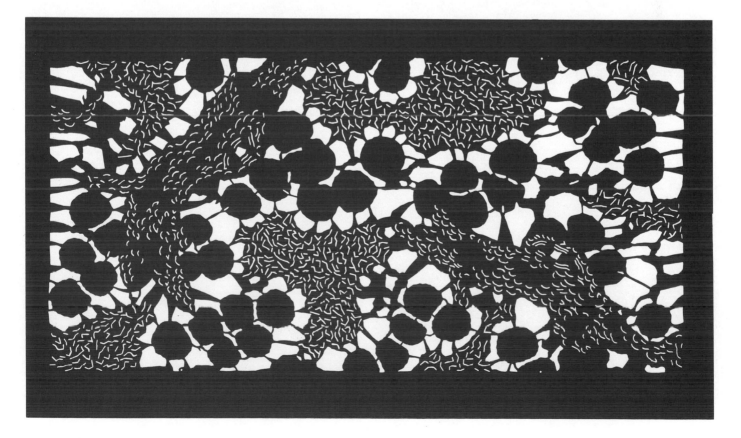

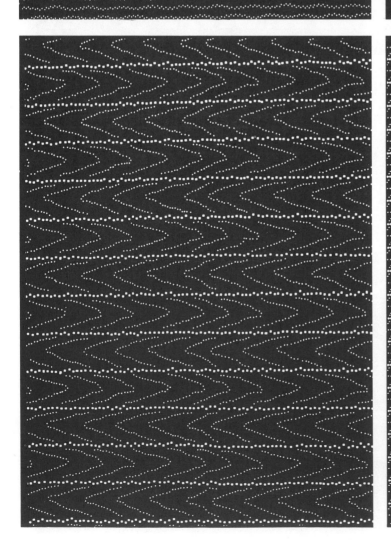

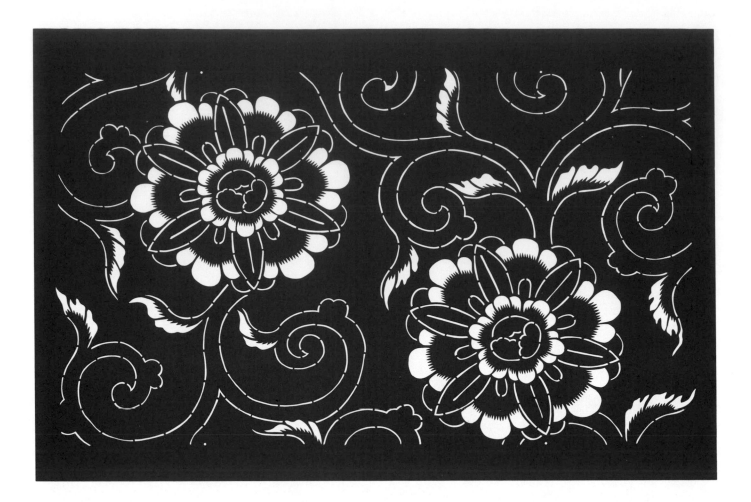

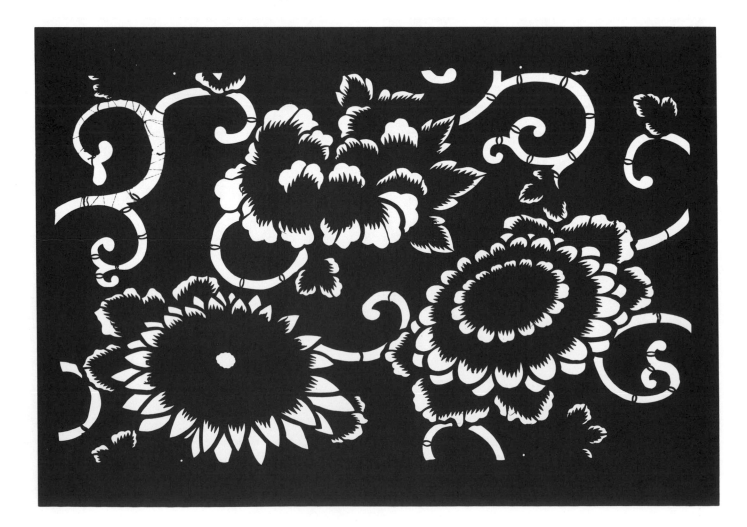

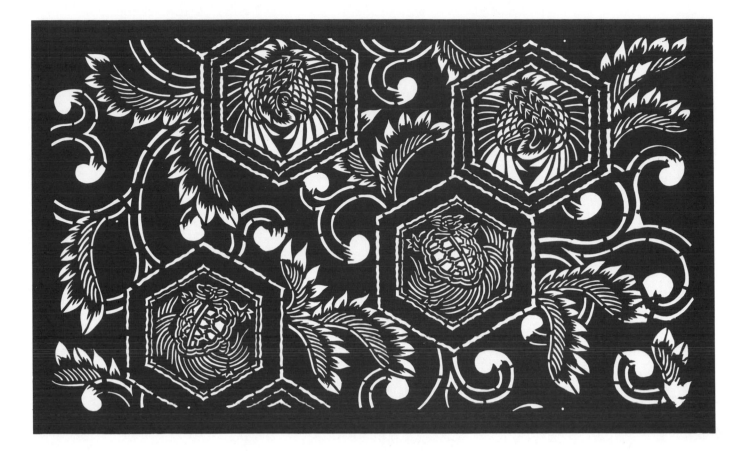

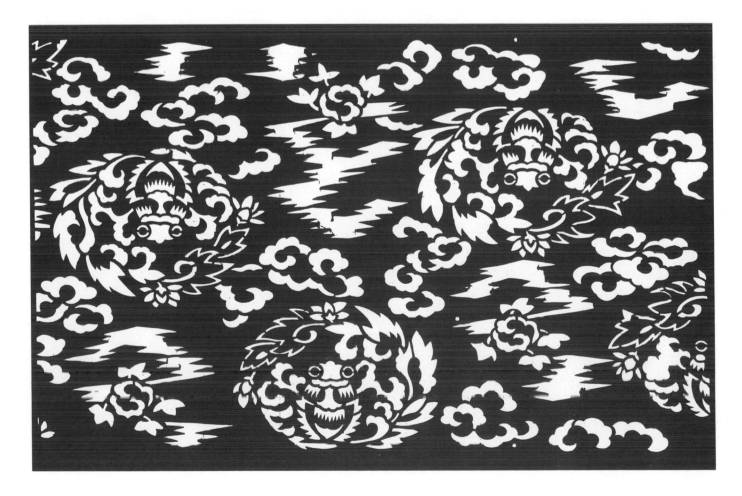

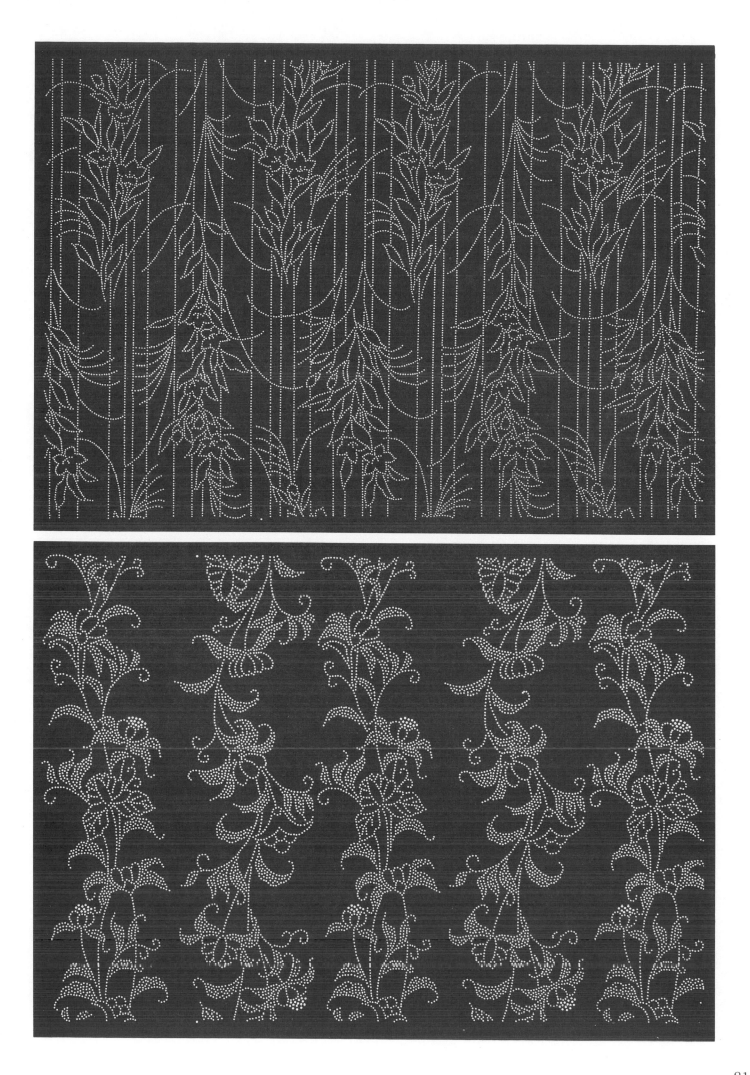

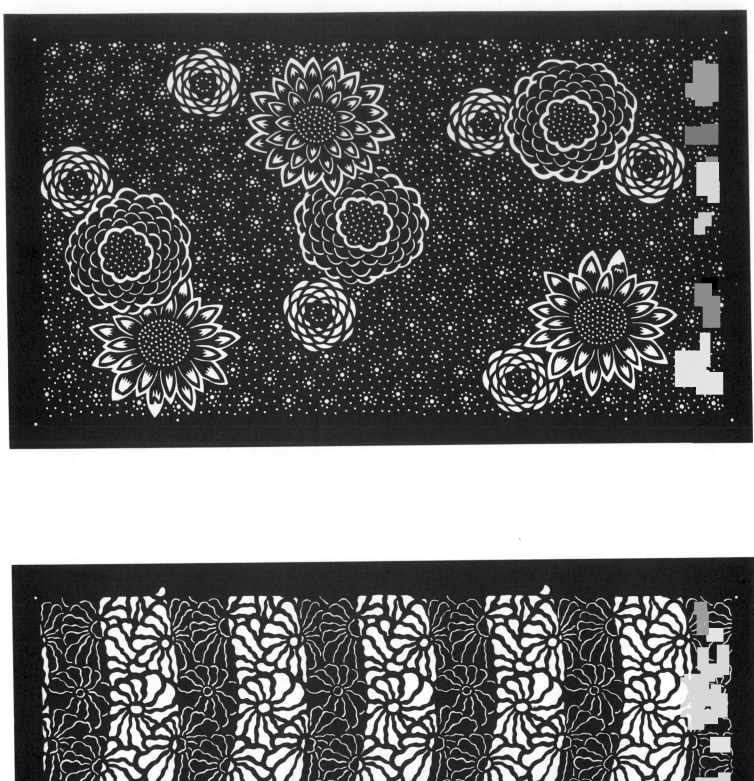

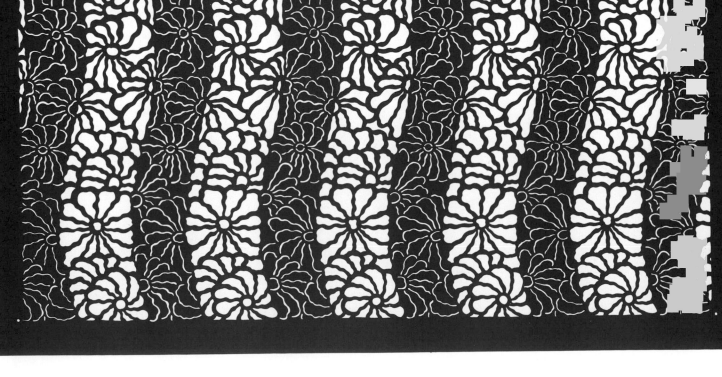

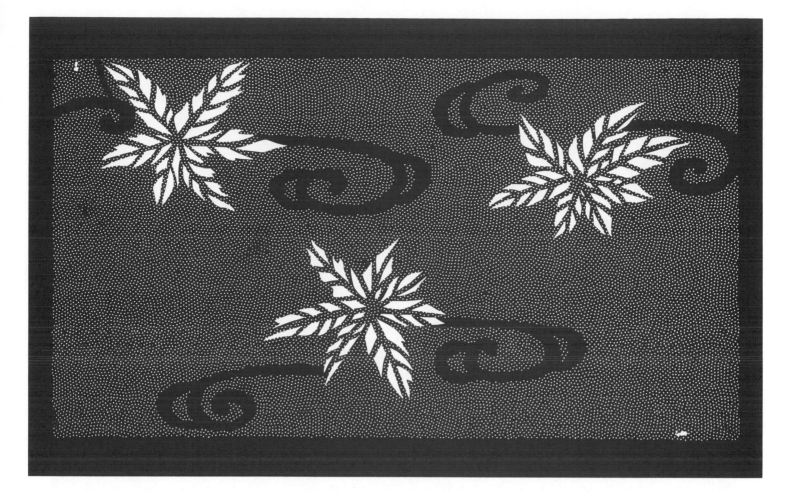

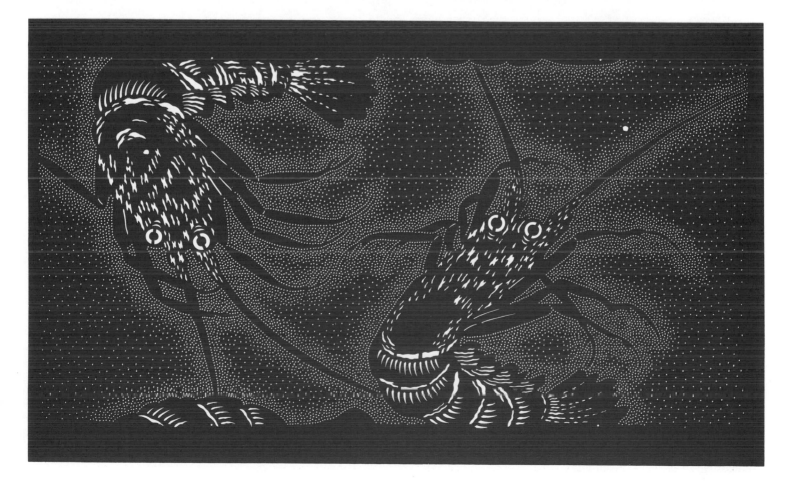

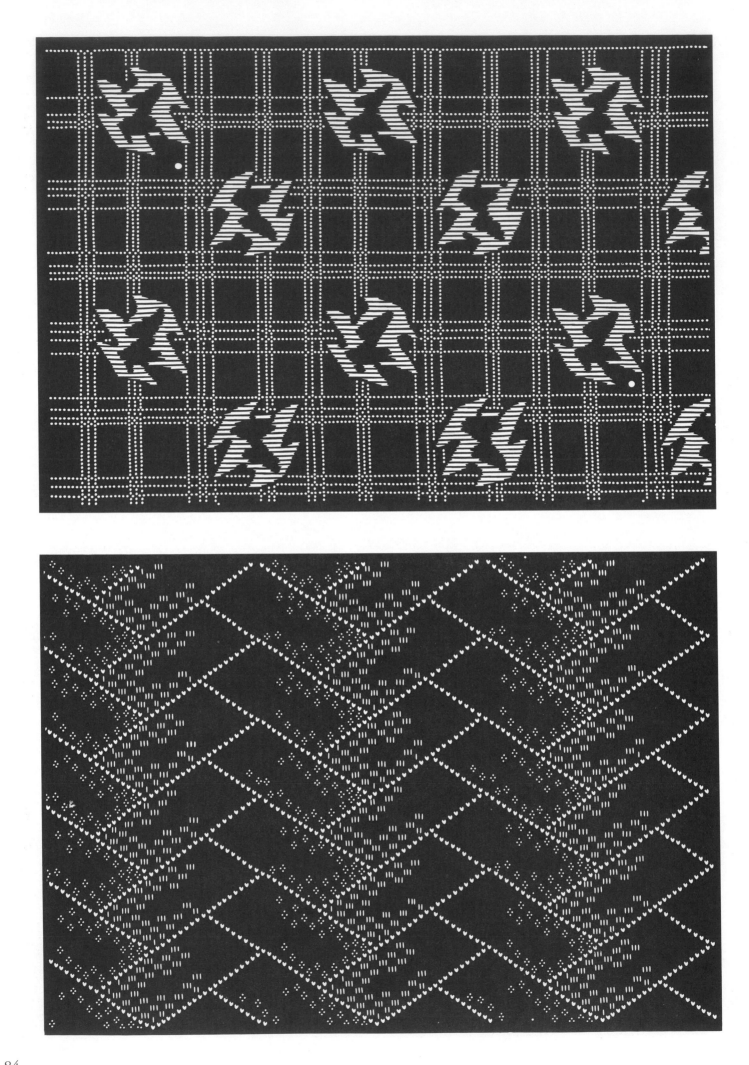

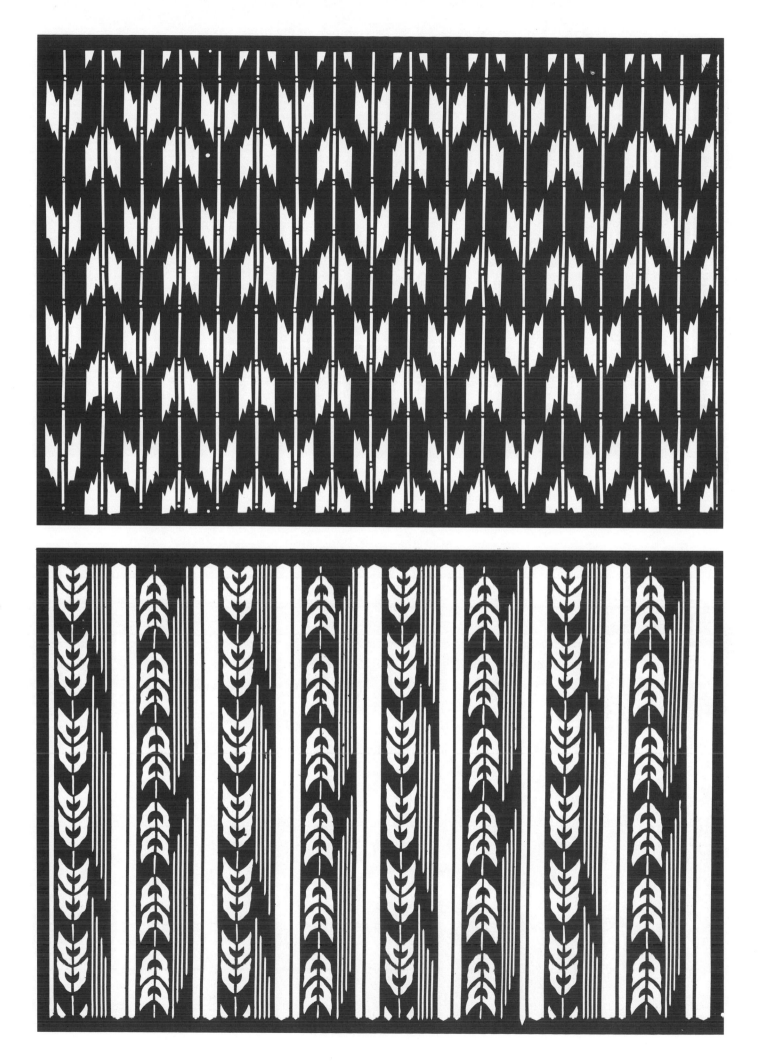

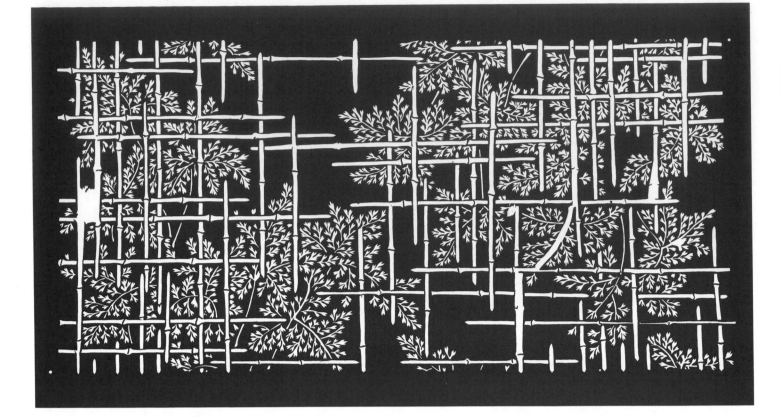

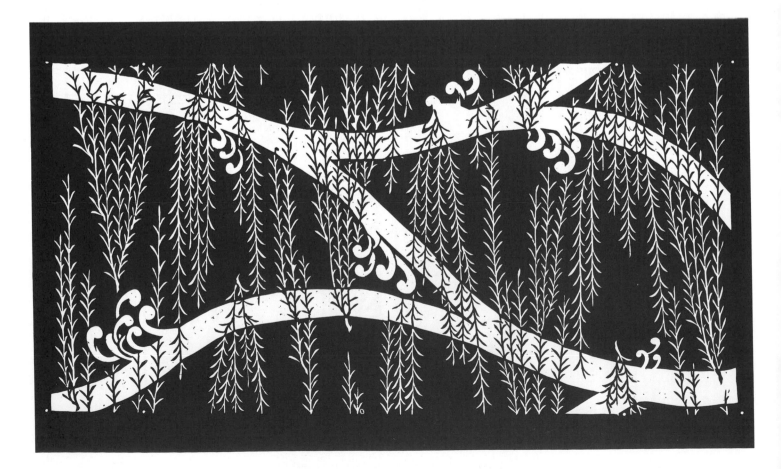

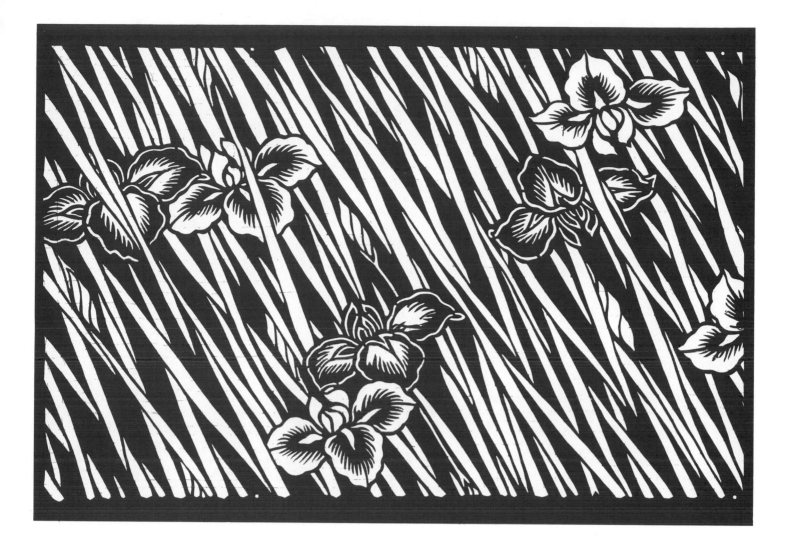

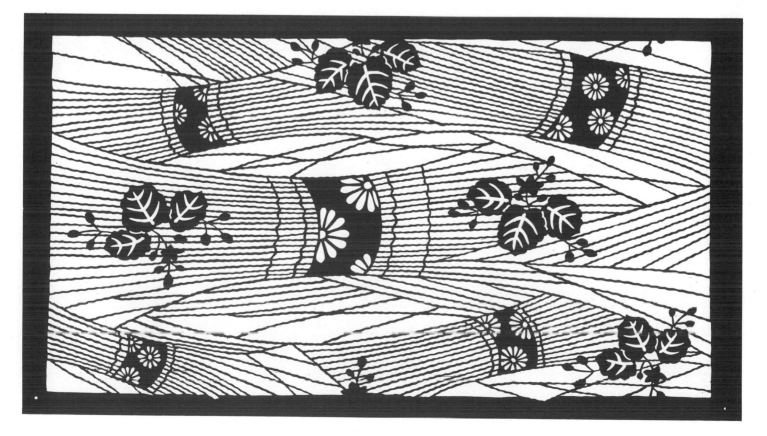

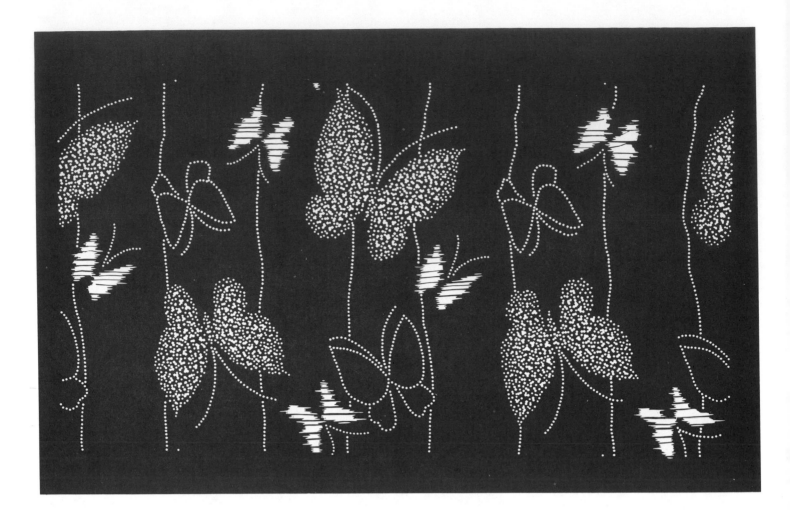

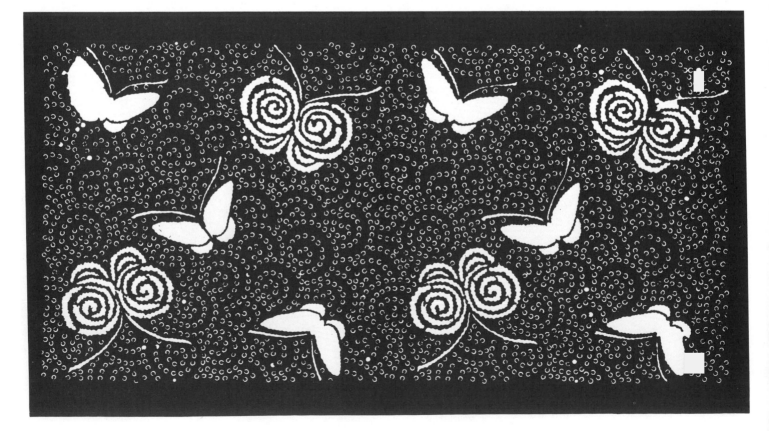

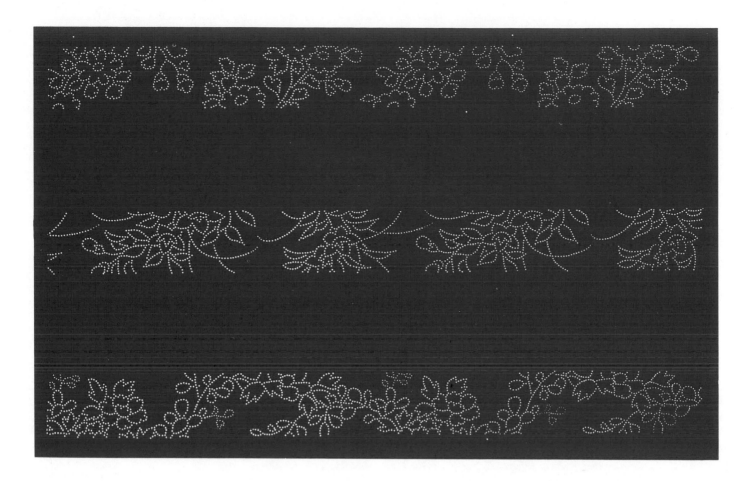

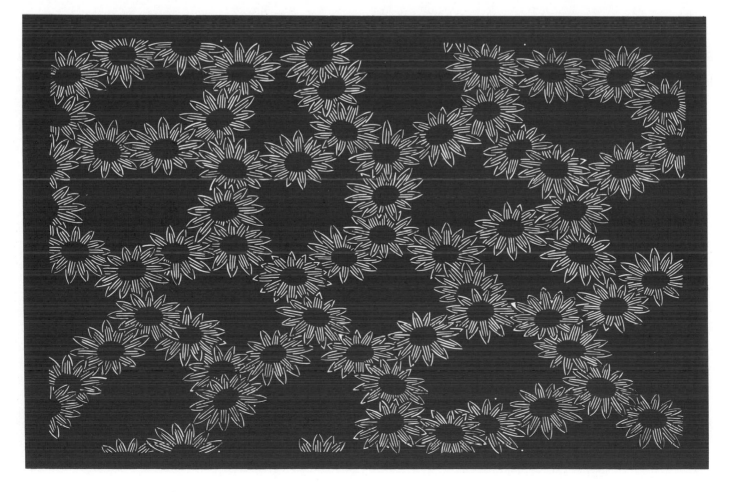

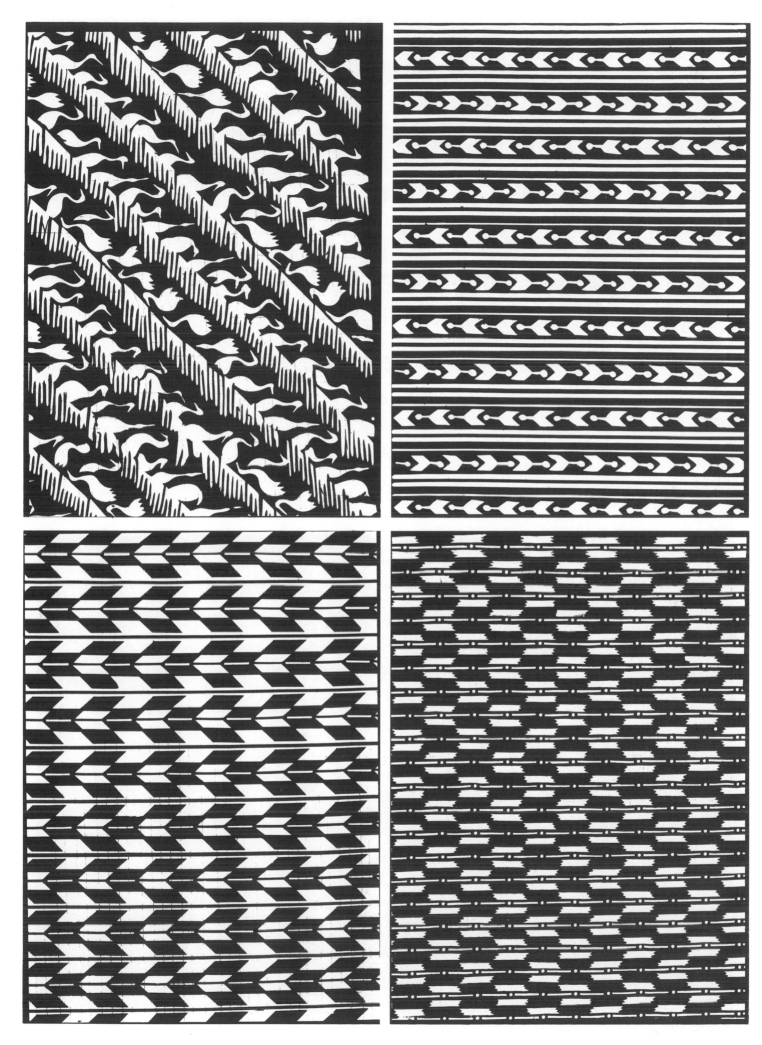

91

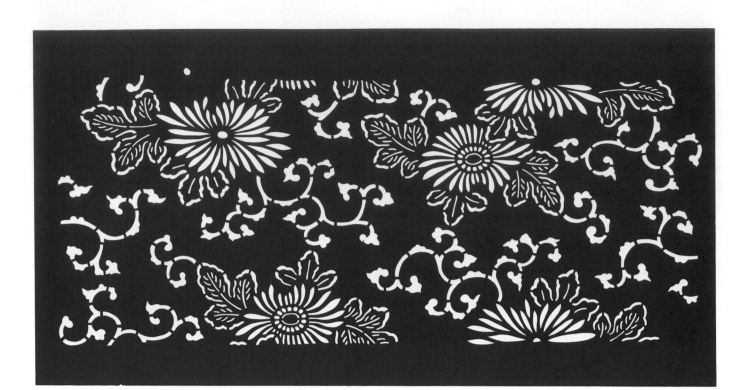

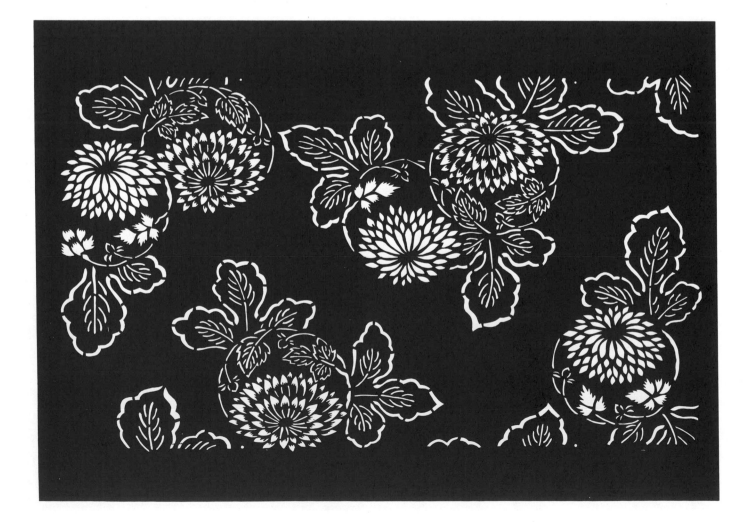

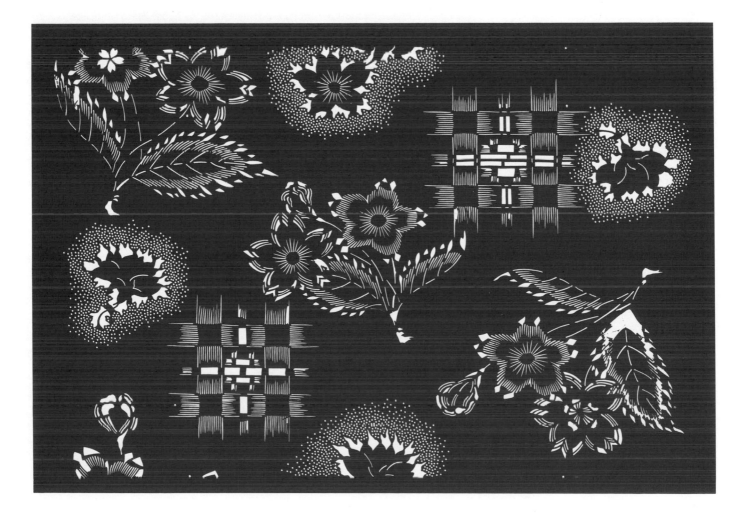

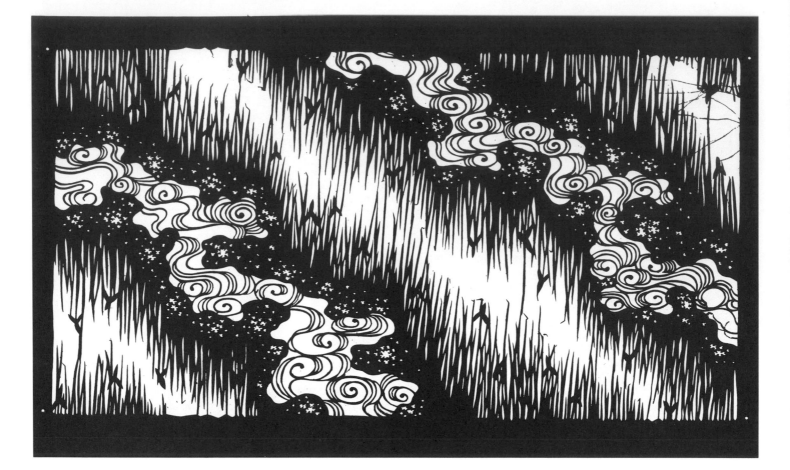

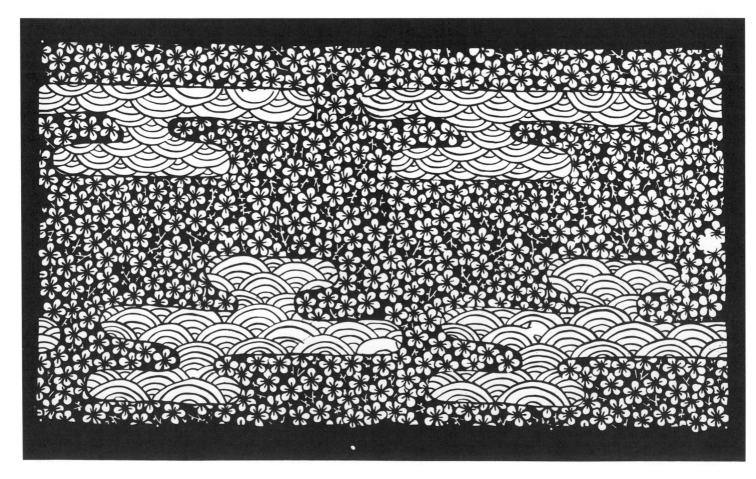

94

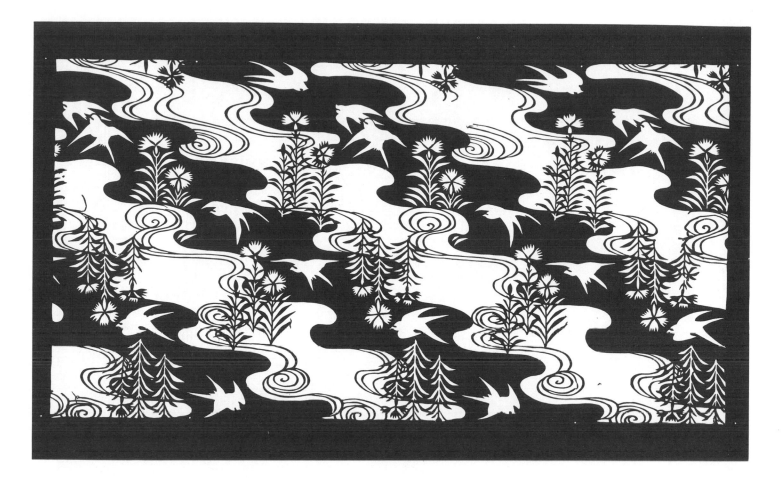

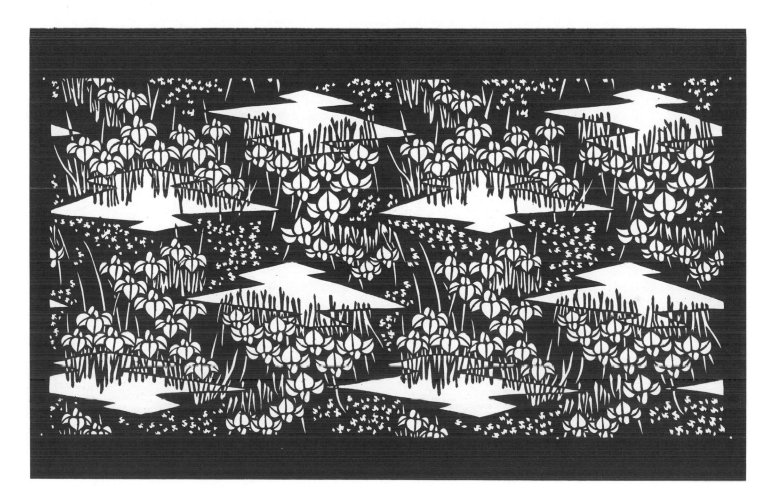

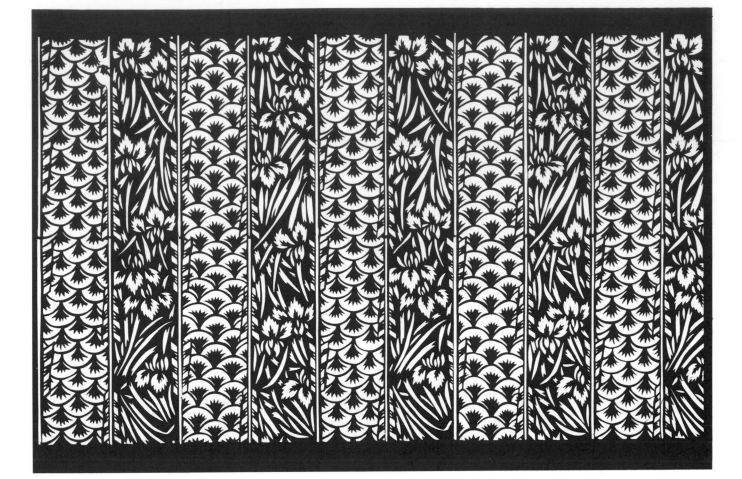

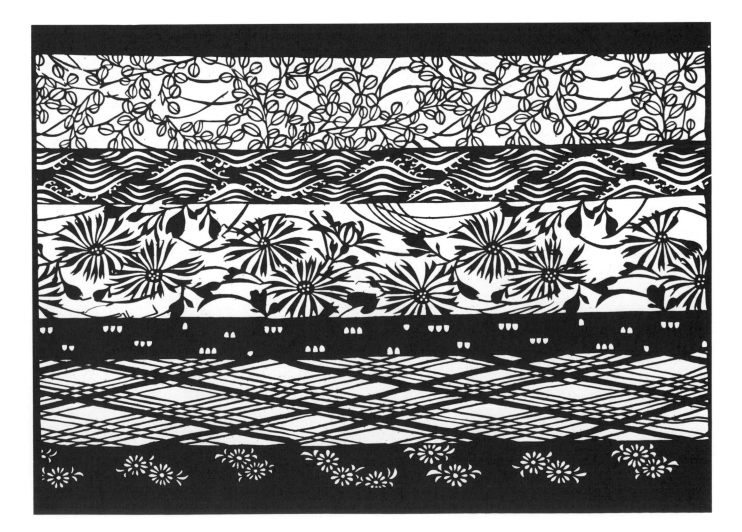

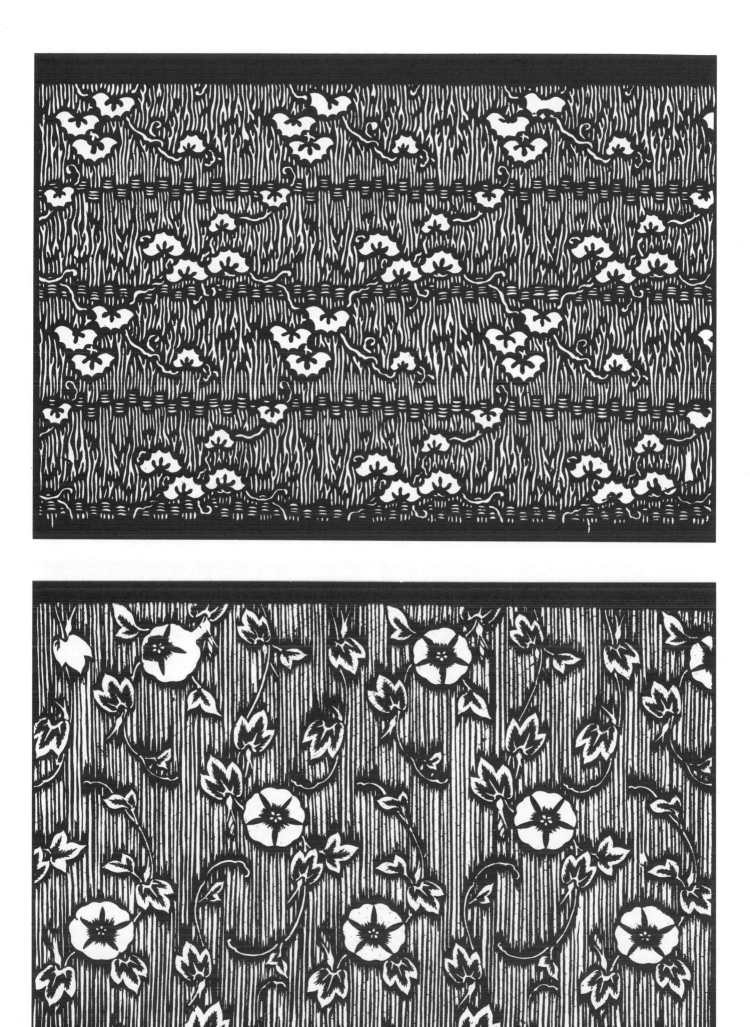

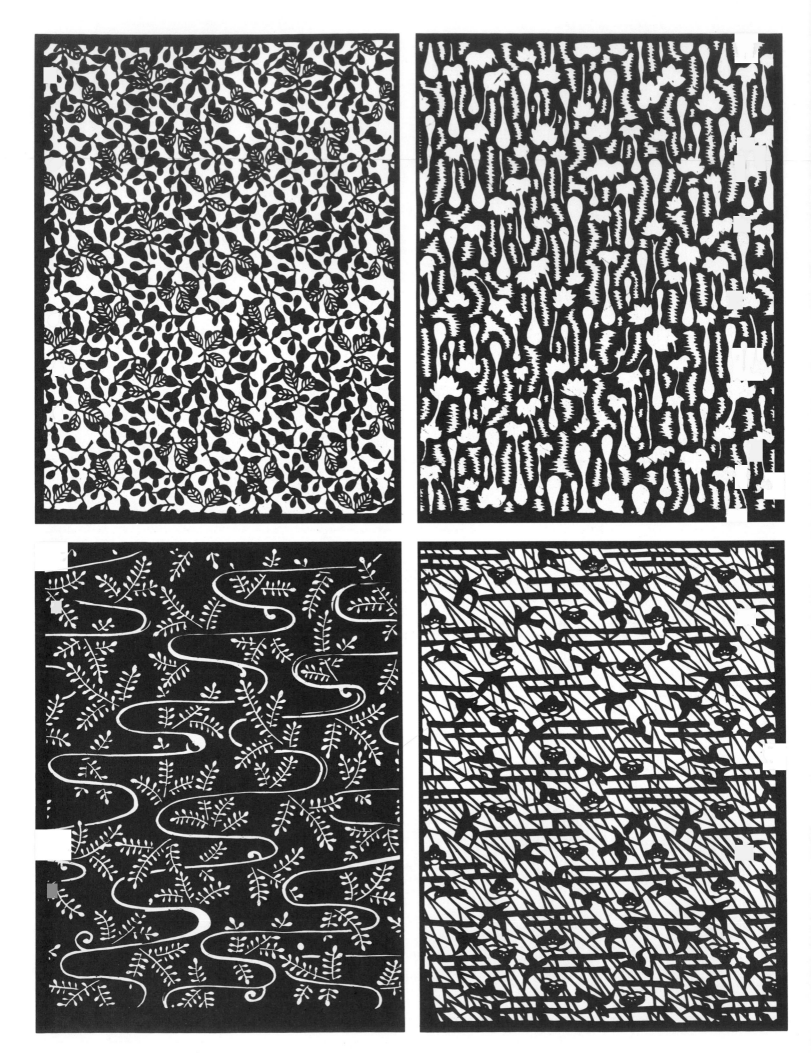

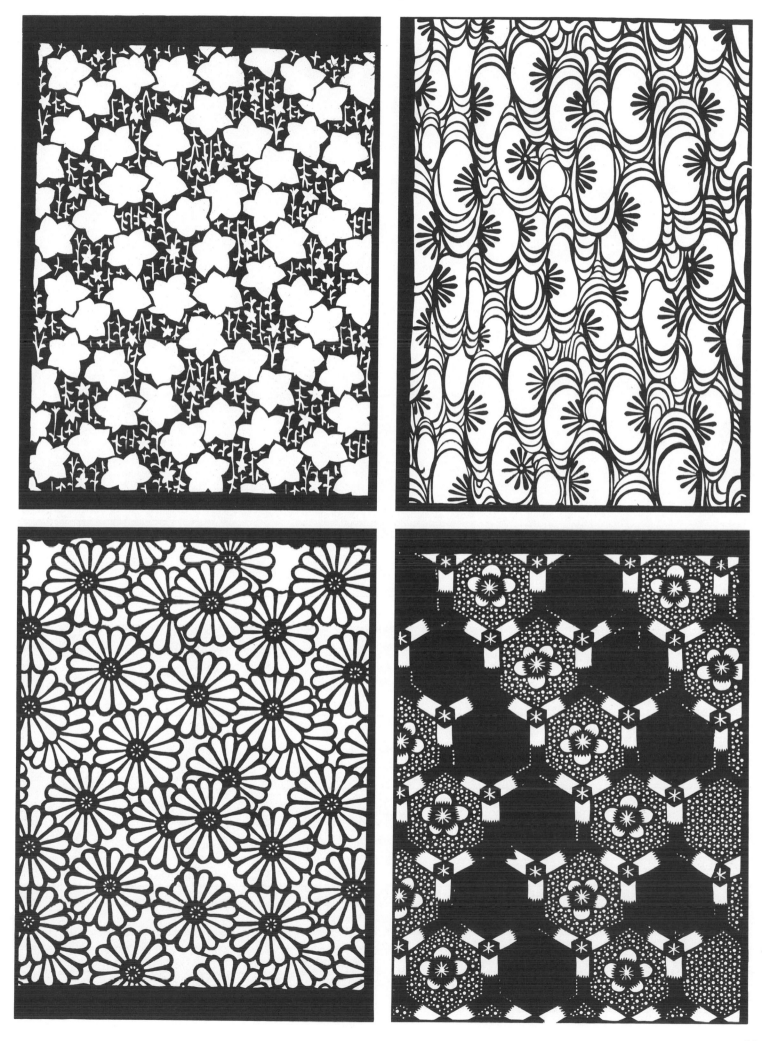

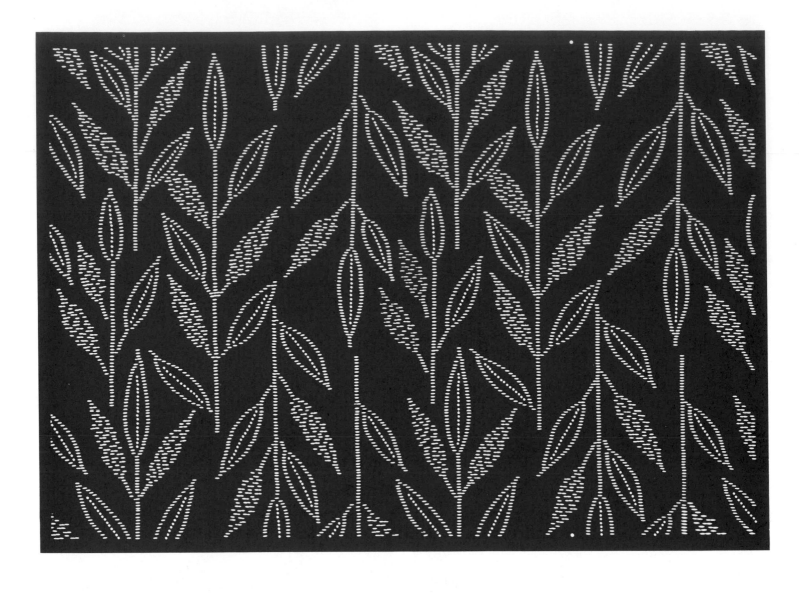

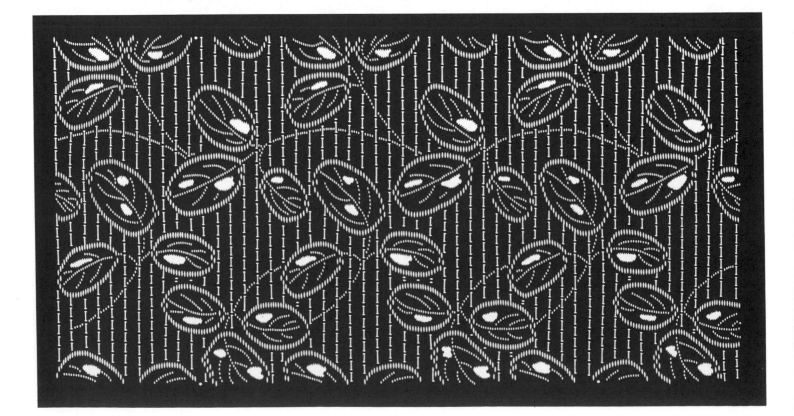

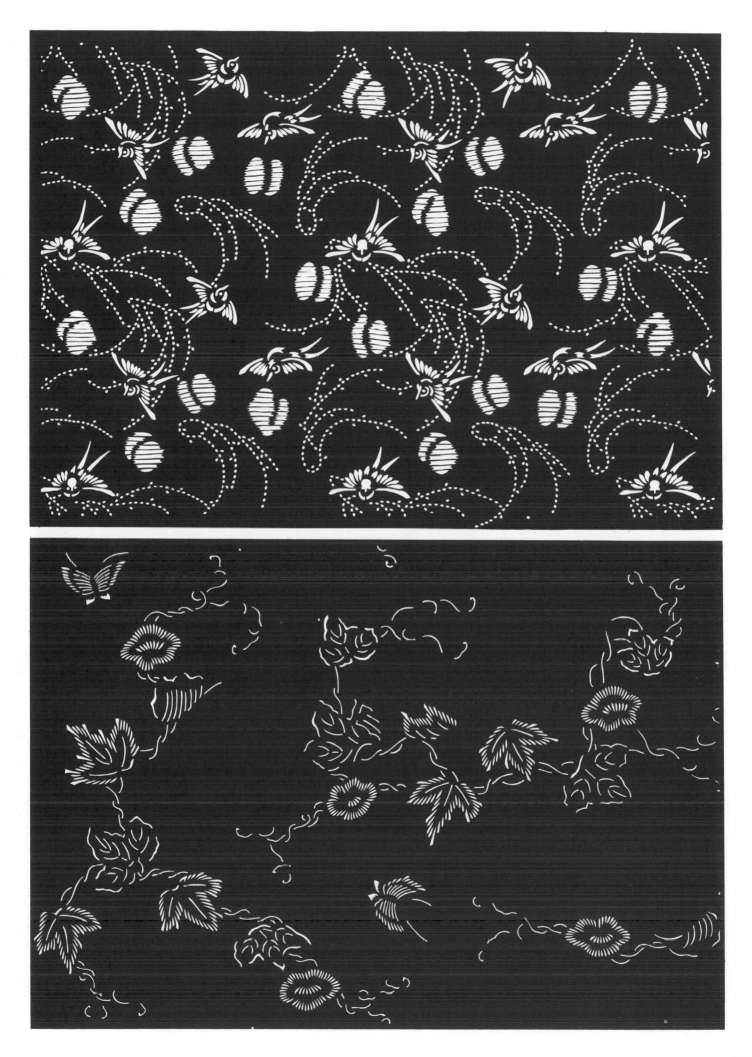

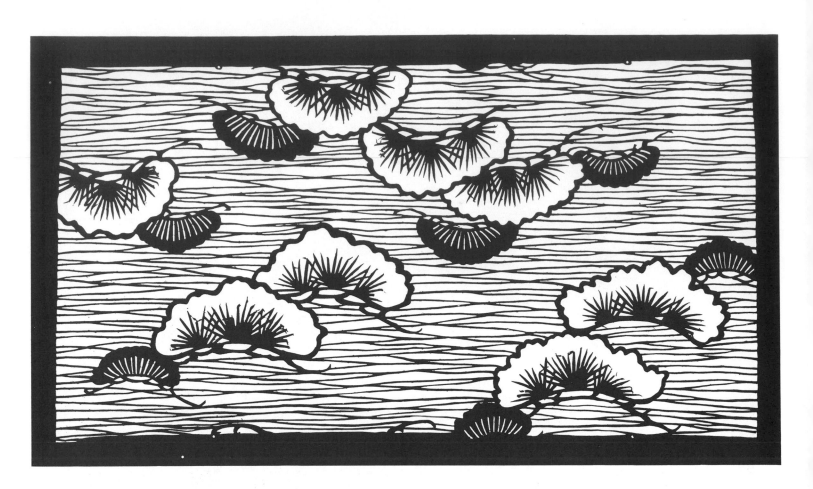

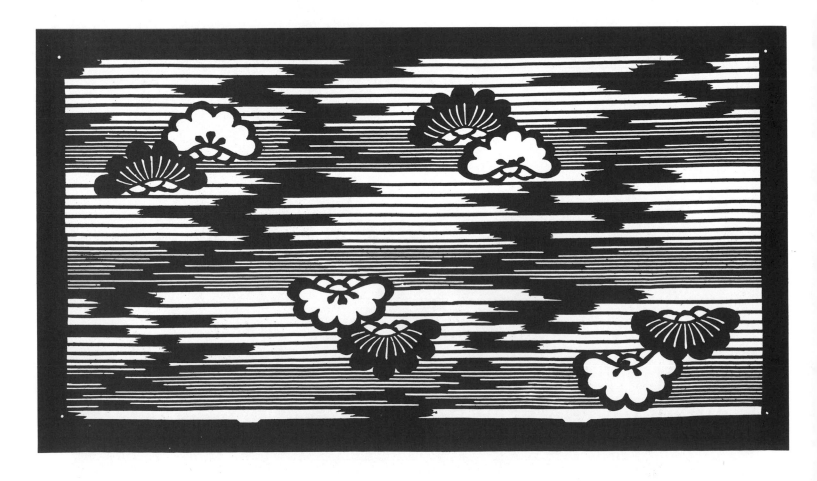

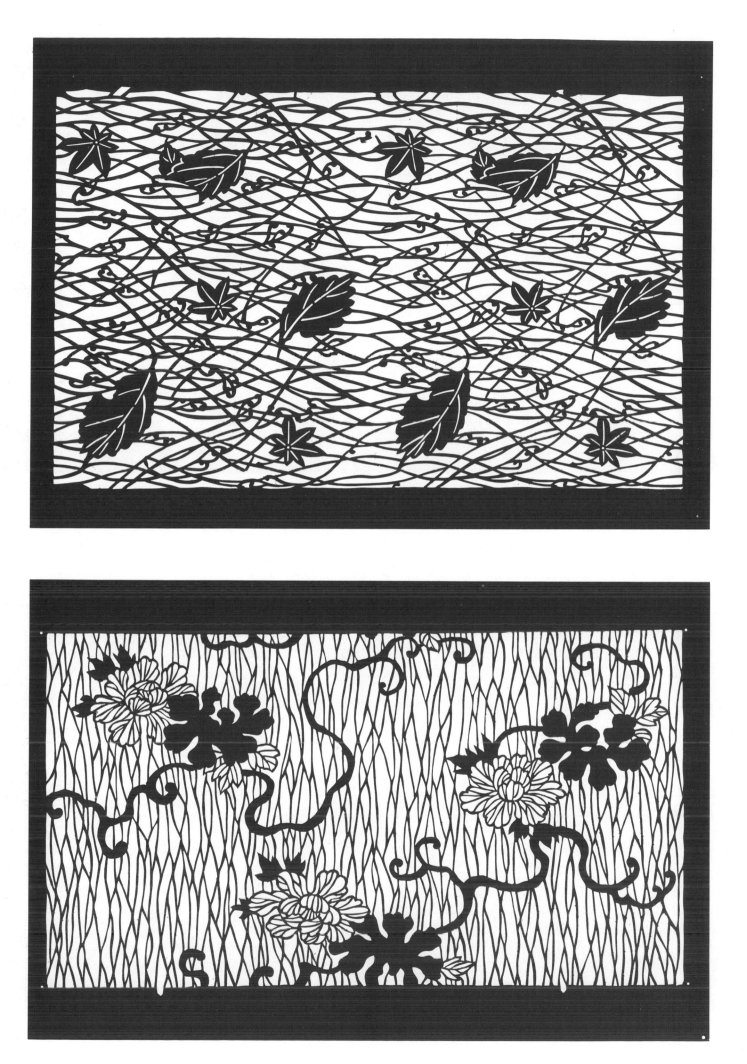

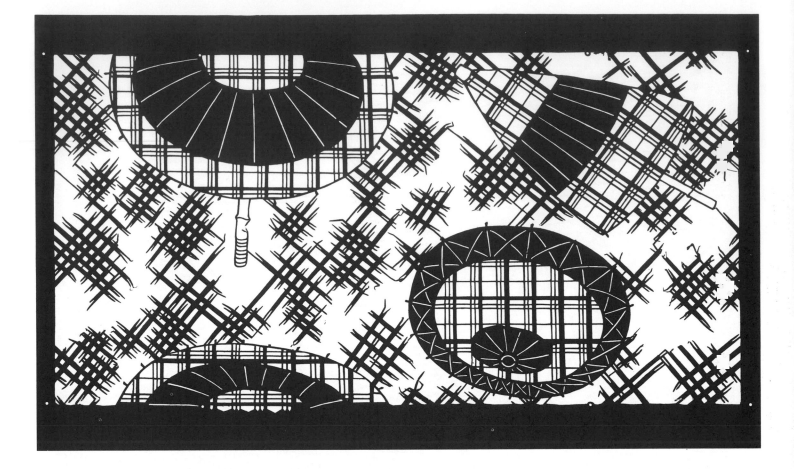

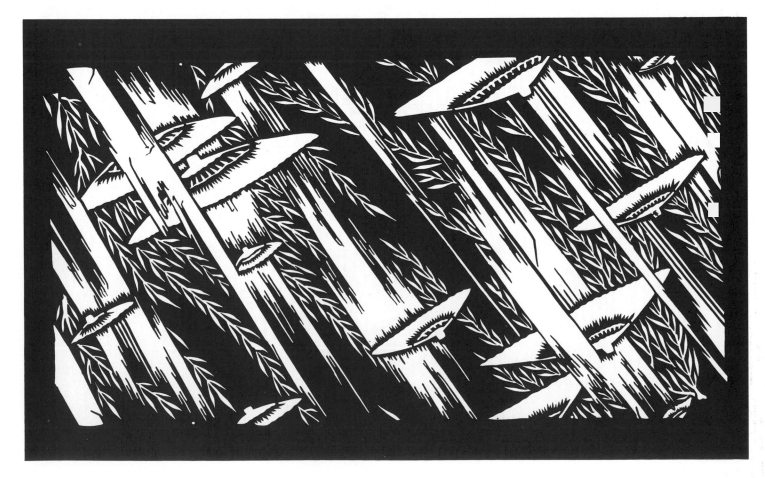

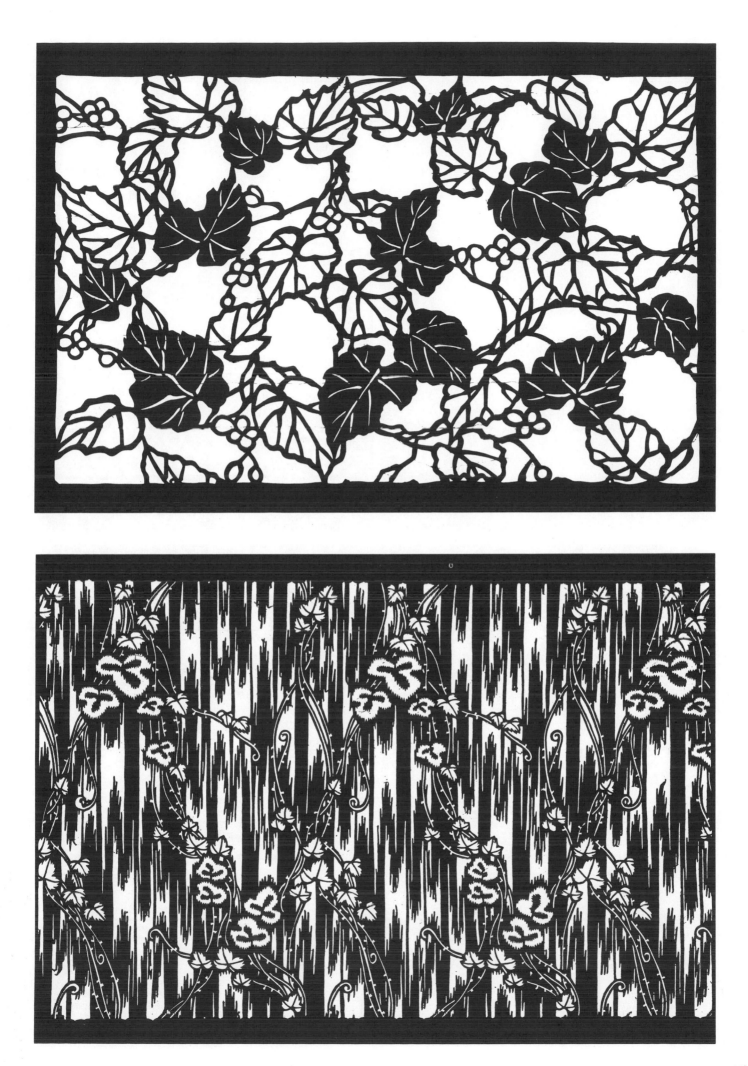

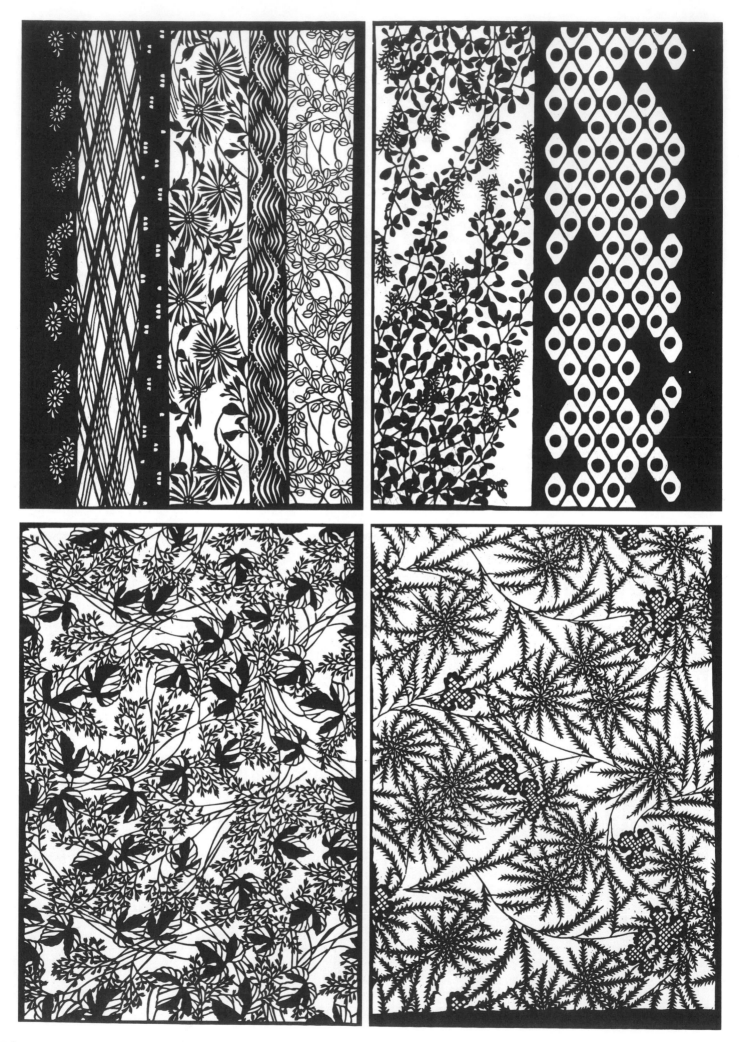

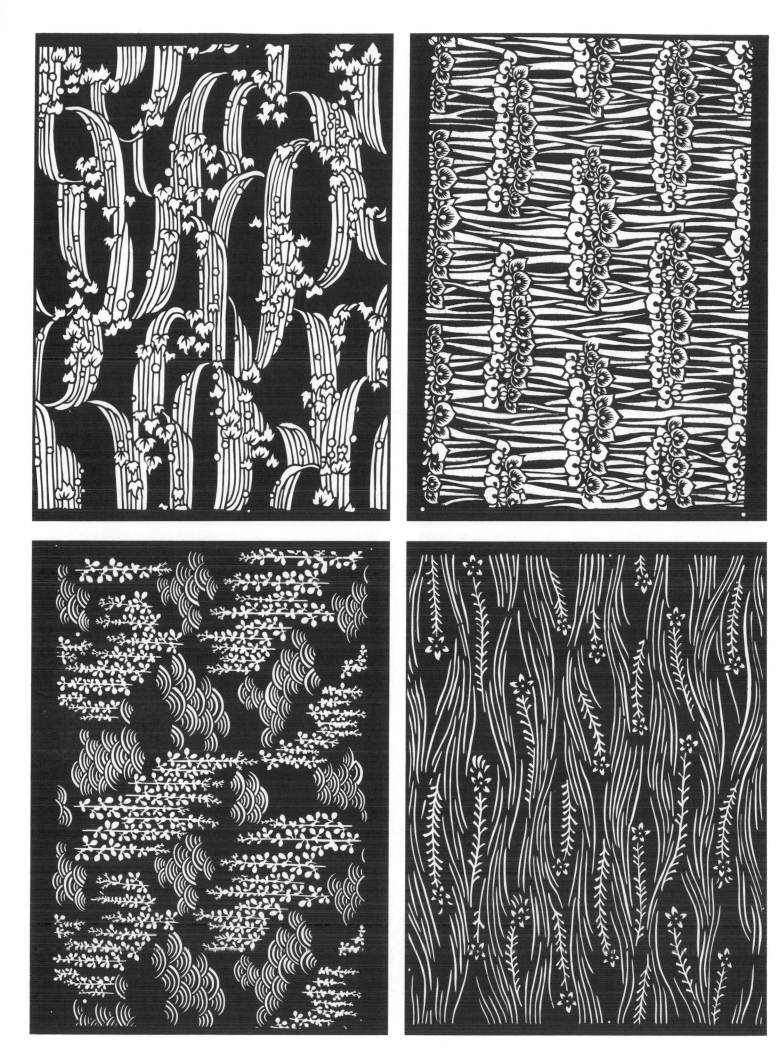

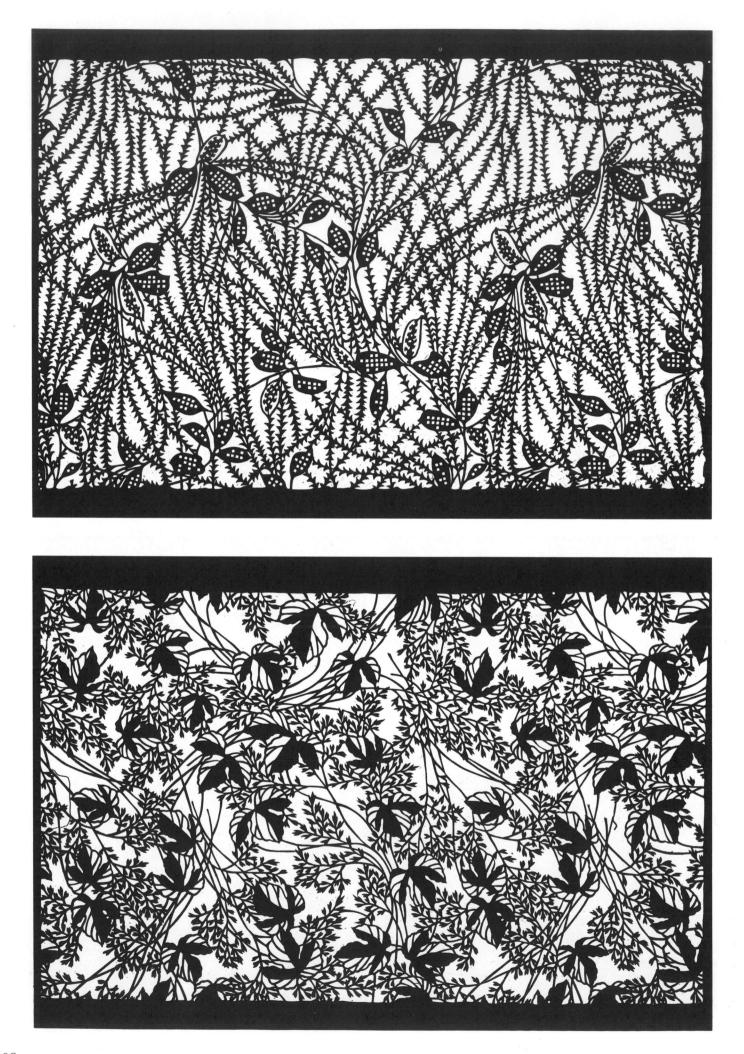

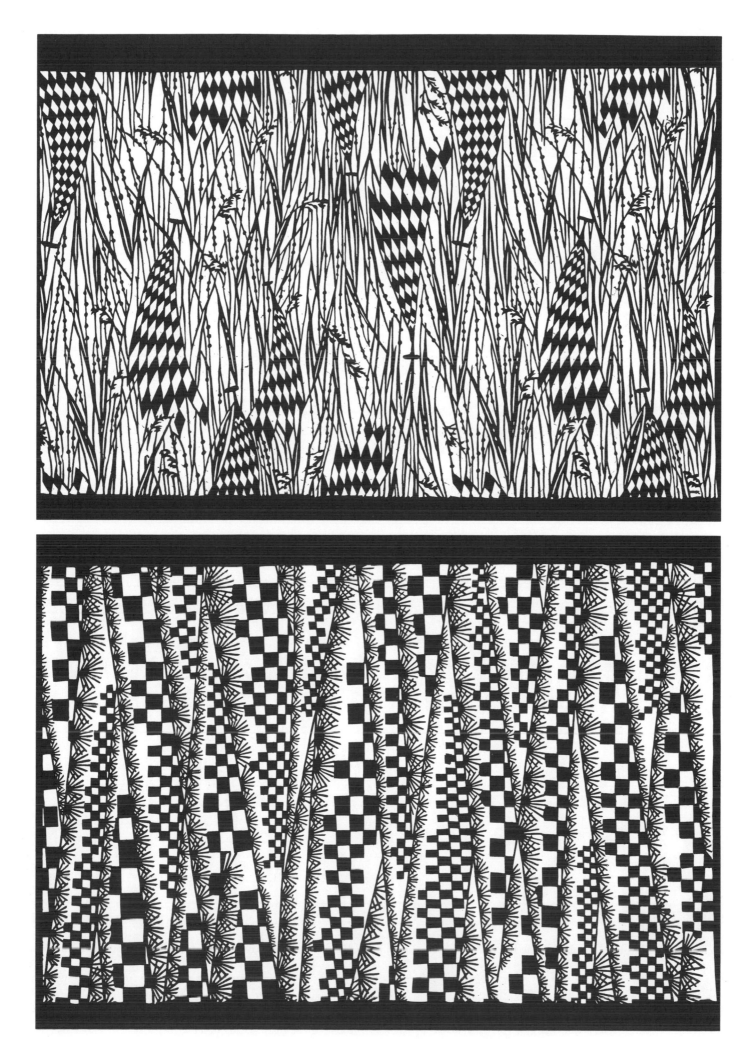

109

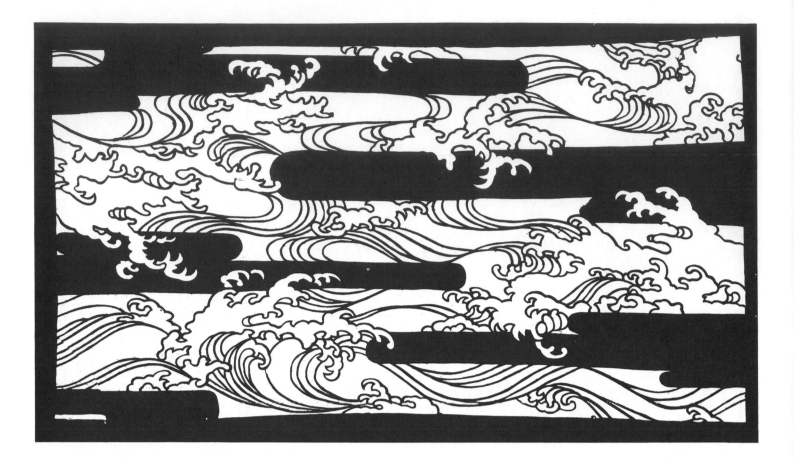

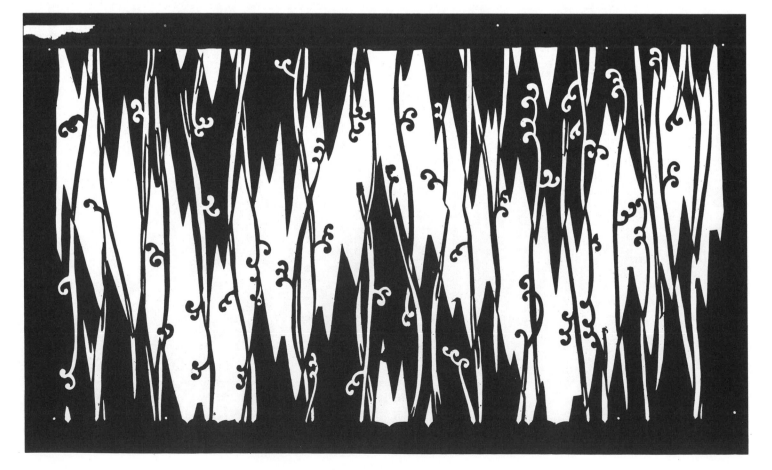

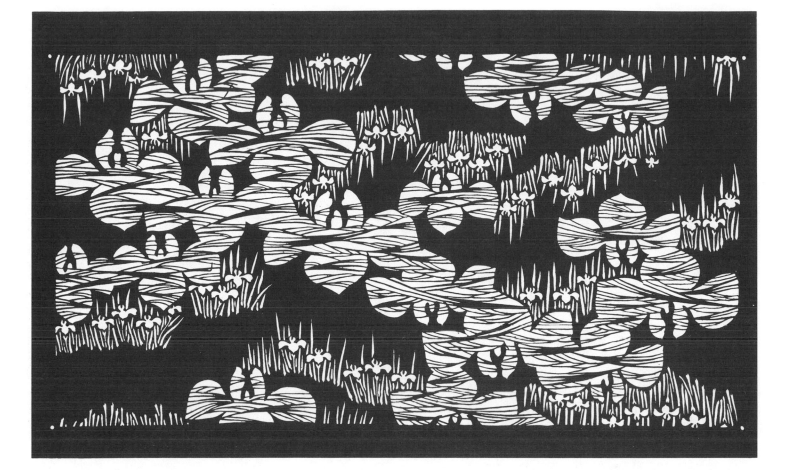

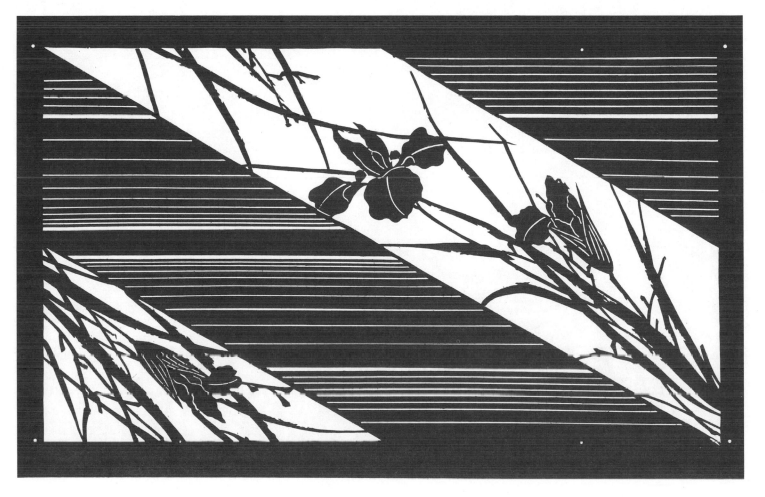

111

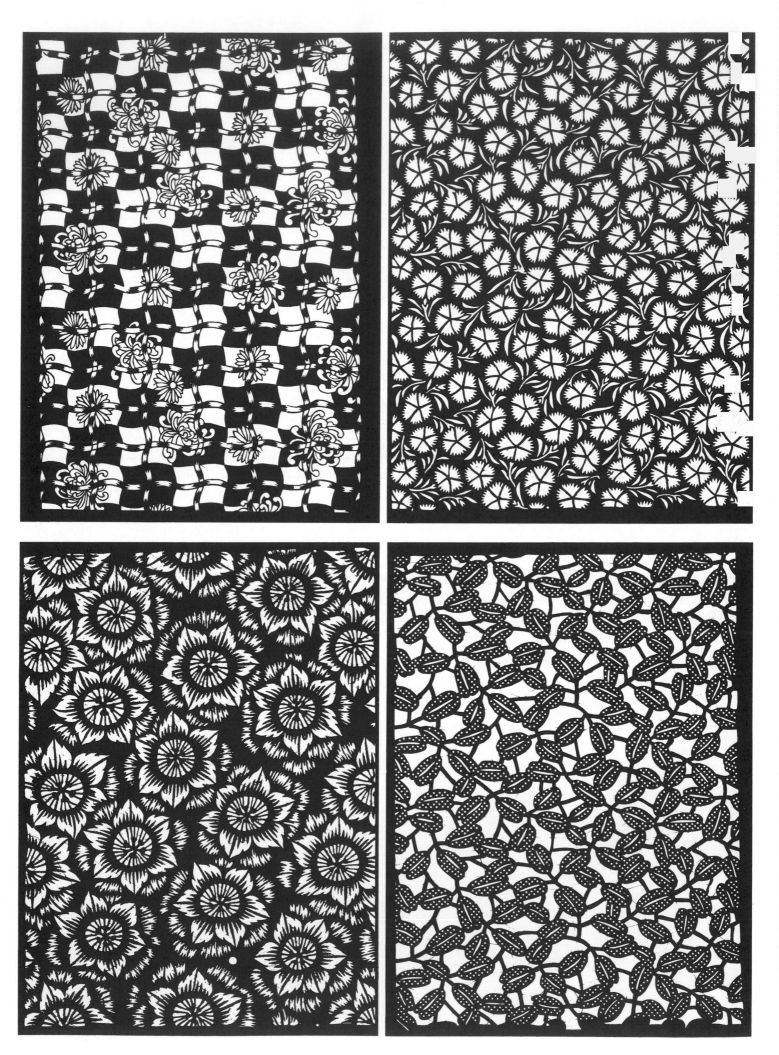

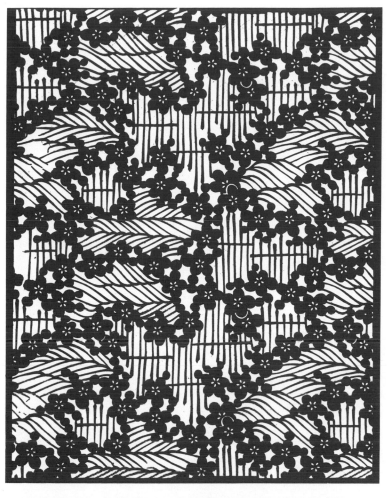
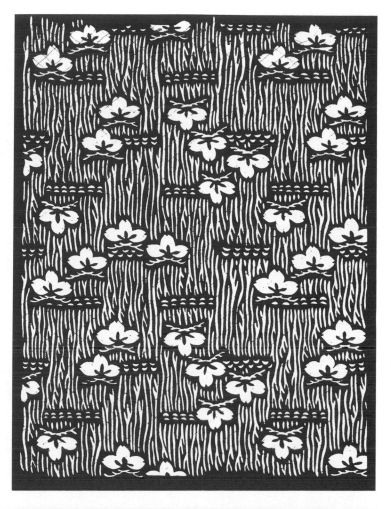
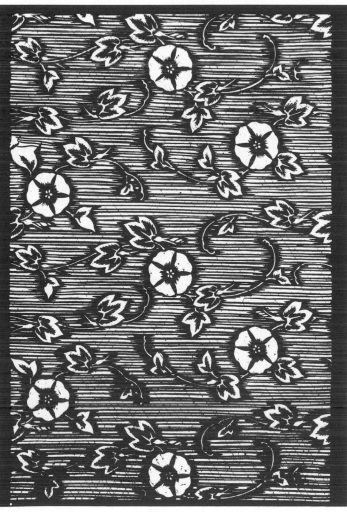
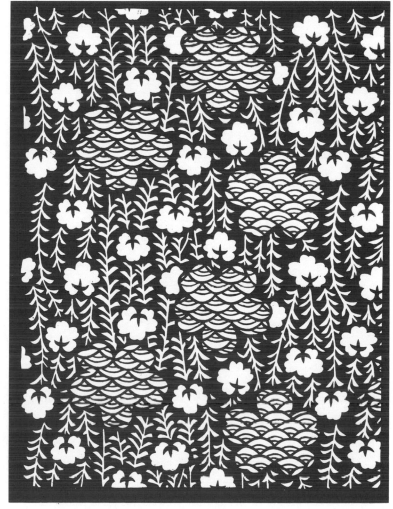

113

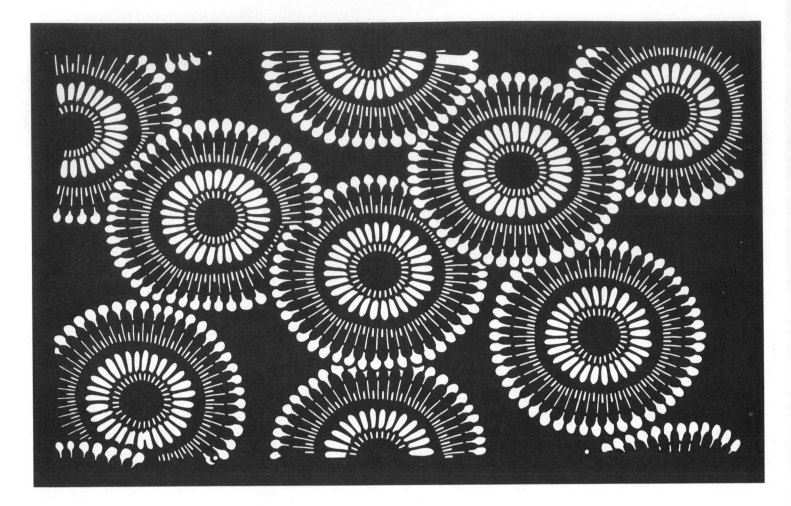

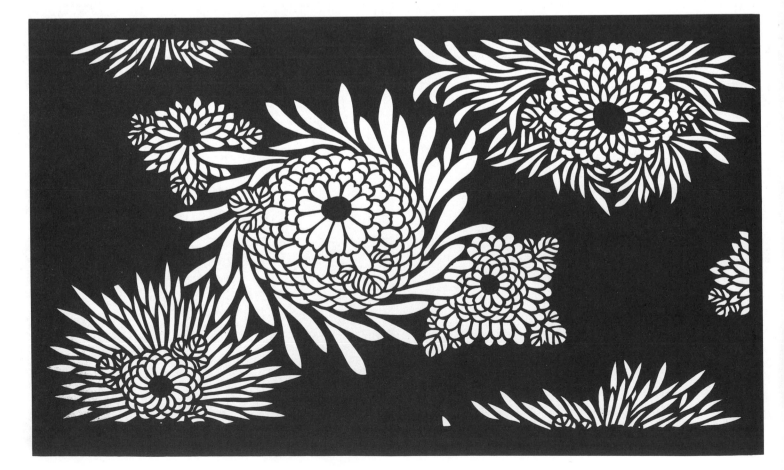

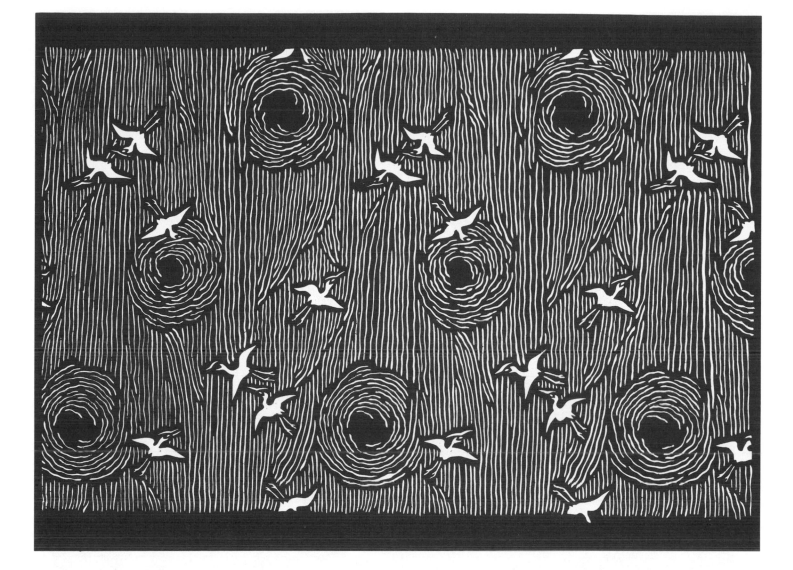

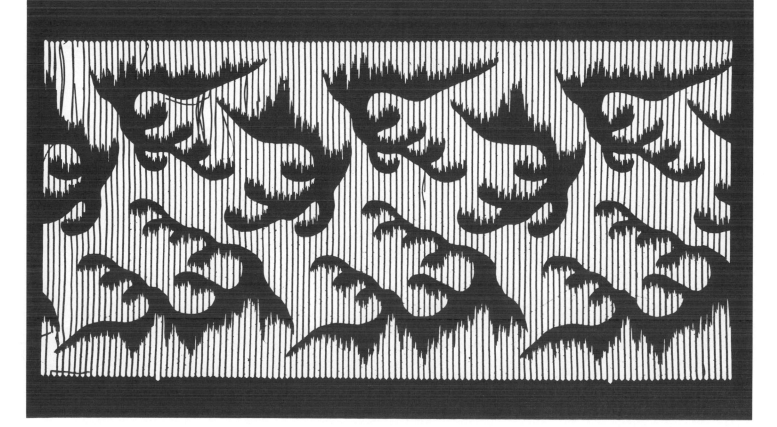

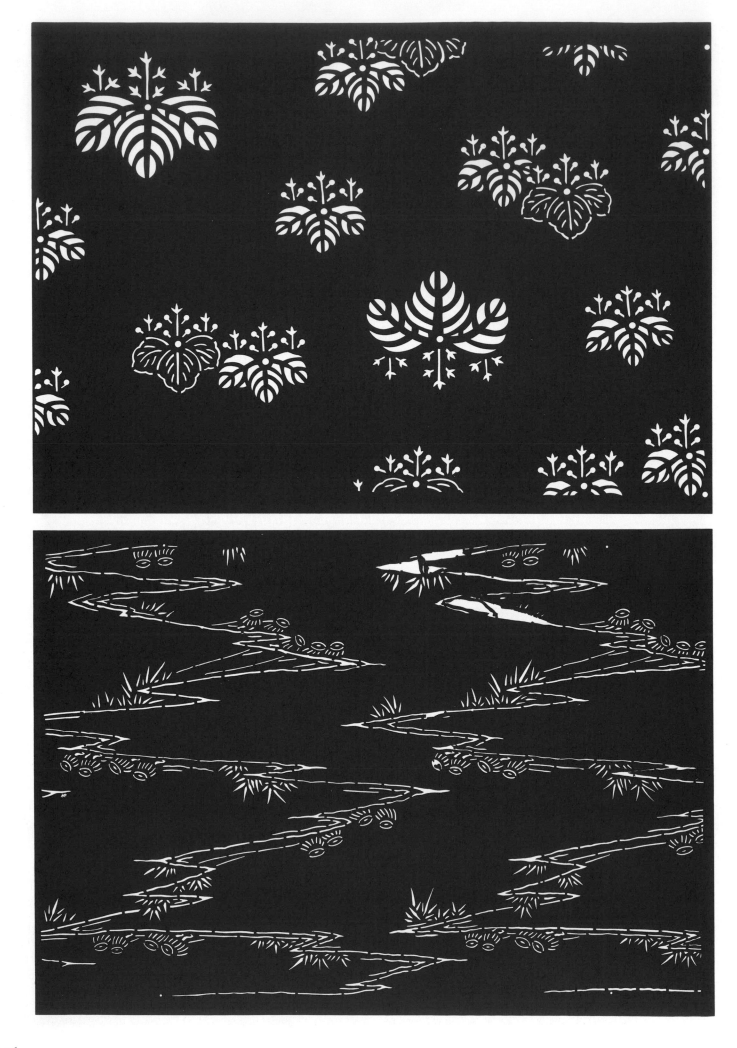

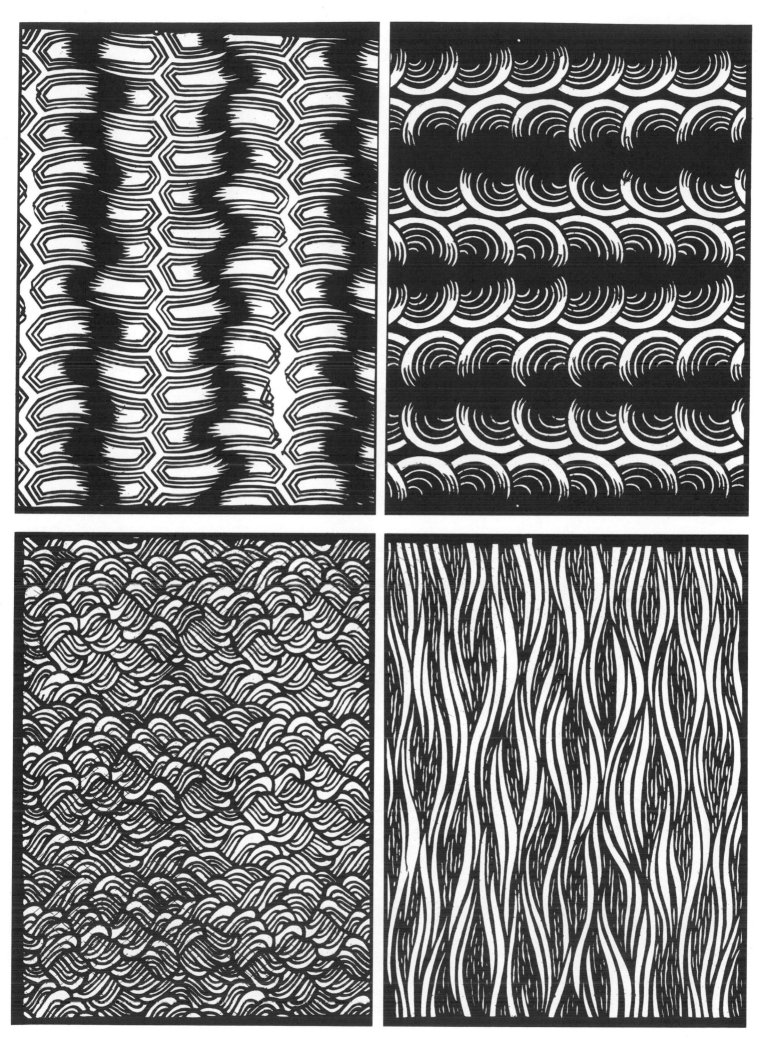

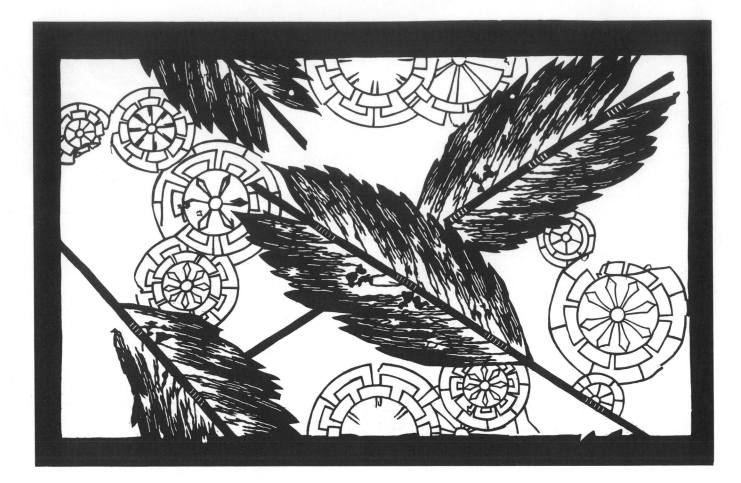

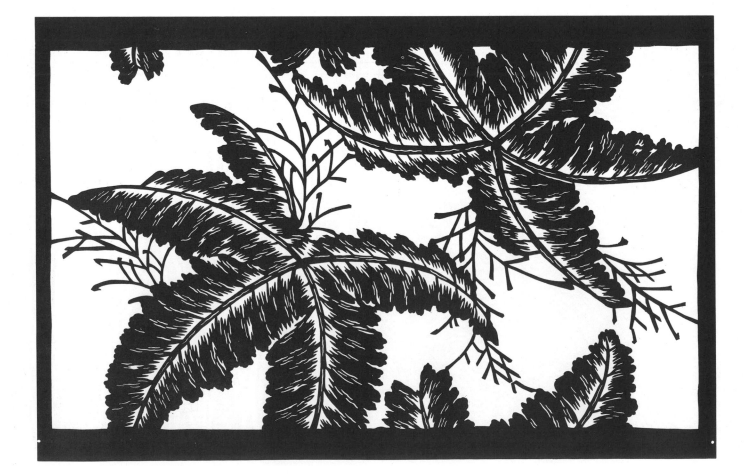

118

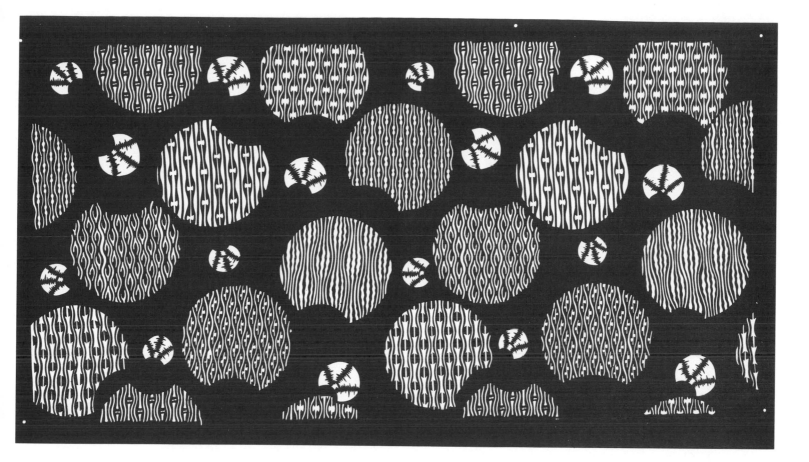

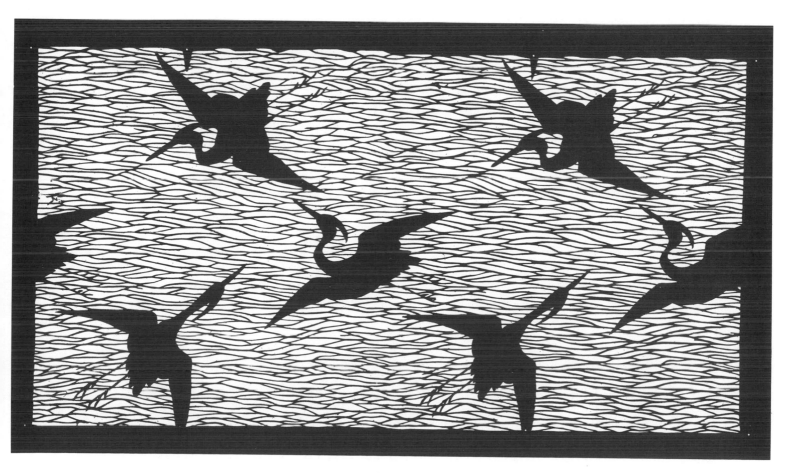